The DC Comics Guide to
DIGITALLY
DRAWING
Comics

Foreword by BRIAN BOLLA

The DC

DIG

FREDDIE E WILLIAMS II

mics Guide to

TALLY
RAWING
Comics

WATSON-GUPTILL PUBLICATIONS/NEW YORK

All artwork, unless otherwise noted, is by Freddie E Williams II

Published in the United States by Watson-Guptill Publications,
an imprint of the Crown Publishing Group,
a division of Random House, Inc., New York.
www.crownpublishing.com
www.watsonguptill.com

Library of Congress Control Number: 2008935969

ISBN-13: 978-0-8230-9923-8

Executive Editor: Candace Raney
DC Comics Supervising Editor: John Morgan
Art Director: Jess Morphew
Editor: James Waller
Designer: Kapo Ng@A-Men Project

First printing 2009

Printed in China

1 2 3 4 5 6 7 8 9 / 17 16 15 14 13 12 11 10 09

FOREWORD

BY BRIAN BOLLAND

I was told the other day, much to my amusement, that I'm a "dead artist." Apparently a page of comic art that I drew twenty years ago was sold to a collector for a surprisingly high sum of money, a sum that's usually reserved for an artist who won't be producing any more artwork . . . because he's dead. (Or, as you Americans like to say, "passed.") Well, I'm currently still in the land of the living and hope to be so for a little while—but, no, I'm not producing any more artwork, at least not in the real world, and haven't done so since 1998 when I went—gasp!—completely digital!

Since announcing that I do my work solely on a computer, I've detected a number of curious reactions in people. When I'm asked what I do for a living, I tell people I'm an artist and for a while bask in their varying degrees of surprise and admiration—up till the moment when I say, "I do it all on a computer." At which point I can see the glow of enthusiasm in their eyes fade, because doing art on a computer is somehow . . . cheating. Presumably, they think you press a button and the computer draws it for you.

Also, if you're an artist, it's assumed that when you've completed your work process you should have a physical artifact to show for it. Something you can hold in your hand or hang on the wall—or, if you're fortunate, sell to an enthusiastic collector for lots of money. Not having artwork to sell is the biggest—and to me the only—reason for resisting the computer.

As long as there have been comics, they've always been "digital"—by which I mean at any one point the printing ink was either there on the page or it wasn't. The printing process dictated that you had black and you had white, and colors were made up of tiny dots of the three primaries: cyan, magenta, and yellow, just the way they are today. We, the artists, were required to provide drawings that complied with those digital restrictions. If we wanted something other than black or white in our drawing we had to do it with shading, scallop-shaped parallel lines, or cross-hatching, any number of techniques that gave the printing machines what they wanted. The artwork was just an early stage in a mechanical process. It was merely information given to a machine that enabled it to produce the glorious thing itself, the printed page.

I work entirely in Adobe Photoshop. (Other applications are available.) There are lots of nifty things that you can do in Photoshop that you can't do with pen and ink. You can enlarge the image or flip it. You can paint a lighter color over a darker color, and you never have to clean your brush or buy a new one. You have a special tool that allows you to draw curves. You can lasso bits of your drawing and move them about or change their size and, at a stroke, you can undo any mistake you make. There are many other things—too many to list here—but try as I might I've never managed to find the button that gets the computer to draw the picture for me, so when the page is finished I can honestly say that it was done by my own fair hand and not "computer generated."

Computers have removed the language barrier between the artists and the machines that print their work on paper. They're clever tools, but they're not for everyone. I recently asked a professional artist if he'd ever considered working digitally, and he replied, "Nah. I think I'll go on getting my hands dirty." Well, I don't know about you, but I'm very pleased he said that and glad there are many more like him, but for those of us who are not particularly wedded to paper or ink or the endless washing out of brushes and pens, the possibilities of digital art—as this book will demonstrate—are endless.

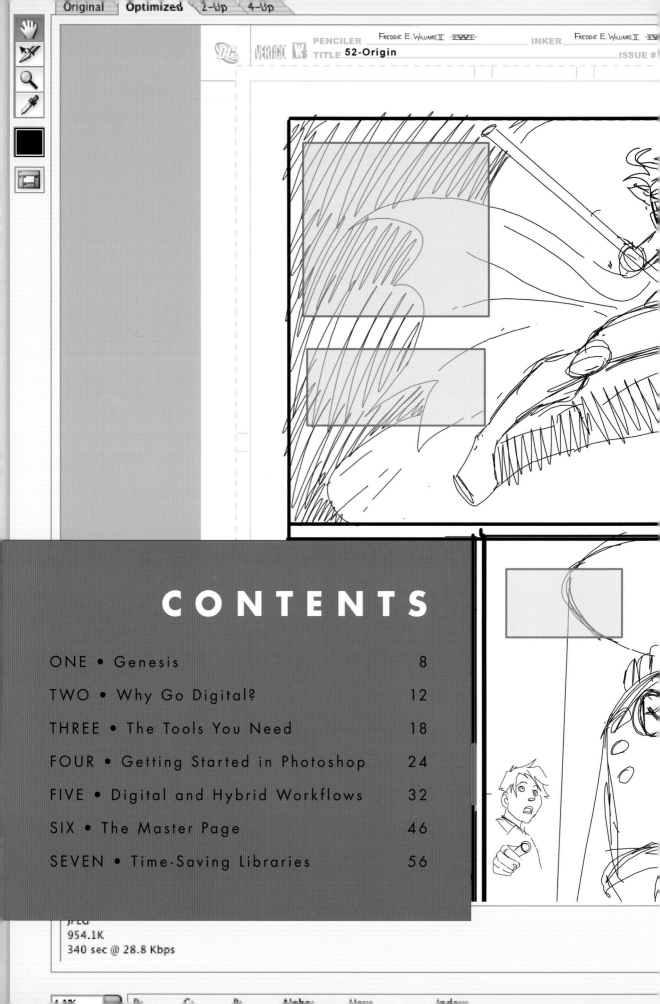

PENCILER FREDDIE E. WILLIAMS II FWI
INKER FREDDIE E. WILLIAMS II FW
TITLE 52-Origin
ISSUE #

CONTENTS

JPEG
954.1K
340 sec @ 28.8 Kbps

Save

Cancel

Done

[Unnamed]

GIF
✓ JPEG
PNG–8
PNG–24
WBMP

☑ Optimized

Quality: 55

Blur: 0

☐ ICC Profile

Matte: None

Looping Options: Once

1 of 1 ◁◁ ◁| ▷ |▷ ▷▷

55 quality

1

GENESIS

Are you ready to throw your pencils and paper away? Ready to learn how to start and finish a comic book page completely on the computer? If so, you've come to the right place! In these pages, I'll teach you several methods for using the computer to draw comics. But before we get into the nuts and bolts of how to create comic books digitally, I'd like to cover a bit of the history of how and why I developed my method of drawing comics digitally—and why I think it can work for you.

My conversion to the All-Digital Workflow began in early 1999. At the time, I was working for a finicky editor at an independent comic book company who asked me to scan in my rough page layouts (which I drew on 8½ x 11 paper) and email them to him for approval. This editor was very hands-on and made several corrections on nearly every page of my roughs.

At first, I made corrections by redrawing the roughs on paper, scanning them back in, and emailing them, but I quickly realized how much time I was spending at the scanner—time I could have used for drawing. So I started making adjustments to my roughs in Adobe Photoshop. Up until then I

Robin and I met at New York Comic Con 2007.
Opposite: Here's my cover for *Seven Soldiers: Mister Miracle #3*. (Colors by Dave McCaig).

had mainly used Photoshop for photo touchups and resizing art for my website, but correcting roughs by flipping, resizing, rotating, and restructuring figures taught me many of the program's tools and how they could be used for comics. As my comfort level increased, so did the amount of time I spent drawing in Photoshop. By the end of that first issue I was drawing all my roughs on the computer.

Soon I pressed further into the digital realm, beginning with creating perspective grids for certain panels. Then I started digitally drawing tight breakdowns for every page, which evolved into very tight structure drawings (which I call wireframes) for my pencils. Eventually, I began completing pages, and finally entire issues, on the computer, from roughs to inks.

Flash forward to July 2005 at the international multimedia extravaganza that is the San Diego Comic Convention. Along with a thousand other hopefuls I turned in my portfolio for the DC Comics Talent Search. The following day, to my nervous delight, my name was on the list of four artists whose work would be reviewed in person. About halfway through that review, I told Richard Bruning, the creative director at DC, that I worked entirely digitally. I was nervous, because most of the established professionals I had revealed this to had responded suspiciously. But Richard replied, "Really?! I couldn't tell." Then he looked over my portfolio again and minutely analyzed all the pages he had already reviewed. He seemed impressed, and I was relieved.

The artwork below is from pages 6-7 of *Robin* #149, the first issue I worked on in that series (colors by Guy Major).

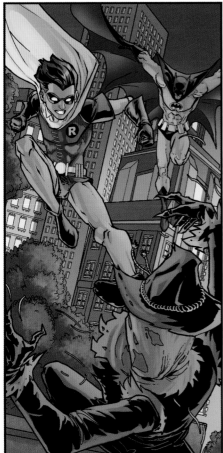

This art is from the origin of Robin in *52* #31 (colors by Alex Sinclair).

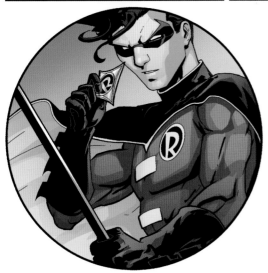

By that October, Bruning had gotten Peter Tomasi, at the time a senior editor at DC, to look at my work. Peter put me on several books that were behind on their production deadlines, and I delivered my art for all of them on or ahead of schedule. In January 2006, Peter asked me to take over as the monthly artist on *Robin,* and I jumped at the chance. In October 2006, almost one year to the day from when I did my first work with DC Comics (and after I had illustrated fourteen issues of various series), I signed an exclusive contract with DC.

The speed, precision, and versatility enabled by my digital workflow has had a huge hand in my success. The book you hold explains that workflow, as well as hybrid workflows for those of you who still wish to produce pencils or inks on a physical piece of bristol board.

I developed my process to marry my loves of comic books and technology, while keeping quality and speed my top priorities. I'm amused to look back and realize that I started working this way because of a finicky editor (with whom I've since become friends) and because of my desire to spend less time at the scanner.

And so, without more ado, on with the show!

WHY GO DIGITAL?

2

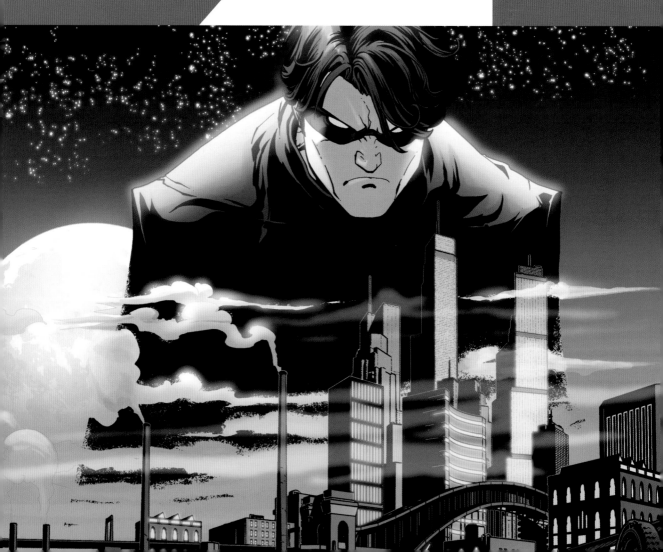

Why go digital? That's a fair question. Many of you reading this already have a workflow in place that you are comfortable with, but you should always be looking for ways to streamline that workflow, eliminating time-consuming and redundant tasks while increasing speed and accuracy. Working digitally does just that!

Computers have revolutionized the comic book industry: Writing, coloring, lettering, and production have all been computerized in the last three decades. Drawing comics digitally is just the next step in this evolution.

I have seen other artists use programs such as Manga Studio, Corel Painter, and Adobe Illustrator to draw their comics. These are all fine choices, but Adobe Photoshop is the primary program I use when digitally illustrating comic books, and it's the program I use in this book. Although I go in-depth in this book about how to create comics digitally, this is not a how-to or step-by-step book on the fundamentals of Adobe Photoshop itself. Instead, the book is targeted at intermediate to advanced users of Photoshop, so if you are unfamiliar with it or any of the other computer programs I refer to, I highly recommend that you look on line for in-depth tutorials, purchase one of the many books on the subject, or even take an introductory course in using Photoshop.

Drawing digitally offers great versatility and a number of time-saving tools. If done correctly, working digitally also offers a higher-quality end result than the standard pencil-and-paper workflow still in wide use today. That's not to say that there aren't drawbacks to working digitally. But after spending a considerable amount of time weighing the advantages and disadvantages of working digitally, I think the benefits far outweigh the pitfalls.

PROS OF WORKING DIGITALLY

References and script are at your fingertips.

Back when I worked traditionally, I accumulated a lot of paper for each page I was working on: script, photo reference, character costume reference, and so on. It was a real hassle trying to keep everything at my fingertips. Working digitally makes things much simpler, because I just place the script and all reference materials for a page in their own separate layer groups. By clicking on the "eyeball" icon in the Layers palette, I have immediate access to the reference I've collected for that page.

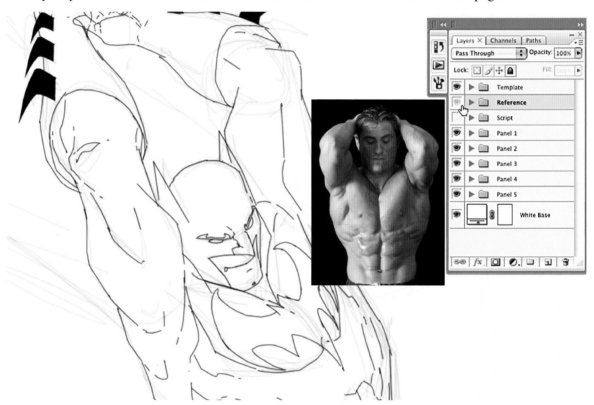

In this example from *Robin* #159, page 12, I was able to check how the muscles under Batman's arm should relate to those on his chest with just a click on an "eyeball" icon.

It facilitates conceptualizing and experimenting.

When you work digitally, there are fewer steps that take you away from the actual act of drawing—less erasing, lightboxing, photocopying, and scanning. In Adobe Photoshop, you can simply create a new layer whenever you have an idea; you don't have to erase what you're currently drawing, and you don't have to sketch different poses or layouts on separate sheets of paper and then cut them out and paste them together by hand.

Reference material, the script, and multiple ideas for poses and layouts—they're all available, and hideable, in the Layers palette.

Working digitally allows you to keep all the stages of developing the page in one file and enables you to try variations of poses and new layouts without damaging your previous ideas. There is no need for lightboxing from step to step, because you are finishing each step right on top of the previous one. This applies all the way through the inking and special-effects stages. You don't have to commit to any idea that you feel uneasy about. When you work digitally, you can alter anything without detriment to the work around it.

You can resize and tweak forever.

Have you ever drawn a hand or head and then noticed that it's too large or just a bit off-kilter? On paper, you have to erase and redraw—and I find that the redrawn element almost never seems as good as the original. But when you're working in the digital world, you can simply isolate that hand or head and then resize, rotate, nudge, or distort it until it feels just right. I have found this sort of flexibility really useful for teenage characters, such as Robin or Wally West's children in *The Flash,* whose proportions and age are especially difficult to keep consistent.

In this example from *Blue Beetle* #15, page 22, I was happy with the shape but not the size of Superman's hand. Because it was drawn digitally, I was able to resize it faster than a speeding bullet.

There's much less scanning.

Saving JPEGs directly from a digital file—to email to an editor for approval—is much quicker than having to physically scan artwork. Moreover, in the traditional paper-and-pencil workflow, you've got to scan the artwork at two or sometimes three different stages of a page's development. When the workflow is entirely digital, though, there's no need for scanning at all. And even if you're using one of the two hybrid workflows I cover in chapters 10 and 11, the amount of scanning is greatly reduced, which means that the time you save adds up quickly.

It gives you cleaner, more precise files.

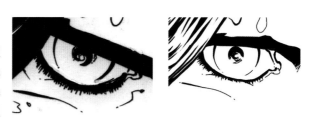

Working digitally creates cleaner pages for all those inkers, colorists, letterers, and prepress guys who will inherit the pages after you're done working on them. And after you create a digital Master Page Template (explained in chapter 6), your pages will automatically be the correct size. This means you can lay out page elements more easily while keeping a close eye on the trim and

Both these eyes belong to the ever-brooding Tim Drake, from *Robin* #166, pages 1 and 2. The eye on the left is inked traditionally using my hybrid ink method. The eye on the right is digitally illustrated from start to finish.

bleed areas of the page. Correct bleeds make letterers and production artists very happy.

Pencils completed using my hybrid method (see chapters 5 and 10) will decrease the amount of time you handle the bristol board, reducing pencil smudging and hand-oil transfer onto the paper and making traditional inking and "direct-to-color pencils" cleaner and faster. When pages are inked digitally, the fact that there's no paper texture makes the file crisper and easier for the colorist to handle. An added advantage is that there's less need to worry about how humidity and paper stock may affect the page you are working on.

You can reuse background and easily adjust spatial relationships.

When you stage figures within a panel digitally, it's like working with animation cells on top of background plate, except that you're using layers in Photoshop rather than layers of celluloid drawings. You can use this method to create what I call "cardboard cutouts" of characters and foreground elements, with a background plate for them to stand in front of. And you can reuse any of these elements later on. In fact, I advocate keeping a library of your backgrounds as part of your time-saving library and reference collection. (More on this in chapter 7.)

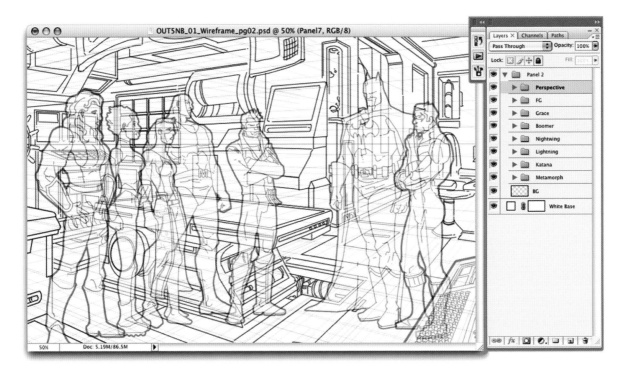

In this example from *Outsiders: Five of a Kind: Nightwing/Boomerang*, page 2, the background is fully drawn out with the figures laid on top of it. The figures themselves are stacked on top of each other, which makes it easy to adjust them to make sure their heights are correct in relation to each other.

CONS OF WORKING DIGITALLY

The up-front cost is higher.

While the prices for technology keep dropping, this does not change the fact that drawing digitally requires a substantial up-front investment. If a friend or co-worker has some of the equipment you need,

you may want to take it for a "test drive" before you spend thousands of dollars. For me, not having to buy traditional art materials, the time I have saved working digitally, and the excitement of learning all these cool new computerized art tricks have more than made up for my up-front investment.

You can lose data because of hard-drive crashes and computer viruses.

We've all heard horror stories about hard-drive crashes and the havoc that computer viruses can cause. All your hard work lost forever! Maybe you've even been the victim of such a catastrophe yourself. Well, working digitally makes these dangers even more frightening, because you're even more dependent on the computer. But there are answers to these problems: backing up consistently and methodically and getting good virus-protection software. The projects that I work on end up getting backed up a total of four times. (I describe my system of making backups in chapter 3.)

You don't have any originals to sell.

There's a large secondary market for original comic book art, which means that the lack of originals may be the biggest downside to working in a 100-percent digital environment. If you work digitally all the time, selling original art is not an option for you because you just won't have any to sell. But, wait, there's still hope! Recently, I've been able to throw my hat back into the secondary market, using my Ink Hybrid Workflow. I choose a few of my most dynamic pages (the pages I think will sell the best) from each of the issues I'm working on and finish them off using a traditional inking method, resulting in original art. (In chapter 5, I explain how you, too, can do this.)

THE TOOLS YOU NEED

3

I have to begin this chapter with a caveat: Trying to list the essential tools for working digitally is like trying to hit a moving target. Hardware and software are always evolving. The high-end computer equipment I use today will soon be the low end. So keep in mind that it's really the methods and the thinking behind this way of working—not a list of specific tools—that I am excited about sharing with you.

Which platform is best—Mac or PC? For over a decade, I have used both Mac and PC computer systems, and I find them equally good for graphics programs. Since JPEG, TIFF, and native Photoshop files are totally compatible between the two platforms, you should feel free to use the operating system you feel most comfortable with.

The commands and tools I use in this book are consistent on both Mac and PC with Photoshop CS3 and CS4, the most recent versions of Photoshop available at the time of this book's publication. However, while the program as a whole has been considerably updated over the years, most of the menus, commands, and tools referenced in this book can be easily found in versions going back to Photoshop 7.0.

All that said, here is a list of the hardware and software I currently use:

- MAC PRO DESKTOP COMPUTER
 4 gigabytes of RAM
 Two 3.0 (gigahertz) dual-core Intel Xeon processors
 One terabyte hard drive
 Internal double-layer DVD burner

This art is from page 5 of *Blue Beetle* #15 (colors by Guy Major).

- 20-INCH ASUS WIDESCREEN MONITOR

 (This monitor pivots and rotates on the fly, so I can put it in the upright "portrait" orientation, which is more appropriate for working on a splash page or a cover.)

- TWO EXTERNAL, ONE-TERABYTE WESTERN DIGITAL "MY BOOK" HARD DRIVES FOR BACKUPS

- WACOM INTUOS3 6 X11 PEN TABLET

- MUSTEK 11.7 X 17–INCH SCANNER, ONE OF THE MORE AFFORDABLE LARGE, FLATBED SCANNERS

- EPSON STYLUS 1280 LARGE-FORMAT INKJET PRINTER

- ADOBE PHOTOSHOP CS3

I also have a 17-inch widescreen PC laptop, of similar power to my desktop computer, that I take with me on working vacations. (Aren't they all working vacations?)

If you have extra cash, you may want to try out a Cintiq, which combines a monitor and a pen tablet in one very useful, very slick unit. I've become acclimated to drawing on a Wacom tablet, but a Cintiq may ease your transition to working digitally because its drawing surface and tactile interface—which allow you to see your drawing tool making a line where you are drawing—more closely recreates the feel of traditional materials.

A WORD ABOUT ERGONOMICS

You should take time to make sure your work environment is ergonomically healthy. It's very important to pay close attention to the positioning of your drawing tablet, monitor, and keyboard, as well as to how you are sitting. Try to create a setup that permits you to keep your wrists level with your forearm, because having even the slightest bend in your wrist as you repeatedly move your hand back and forth

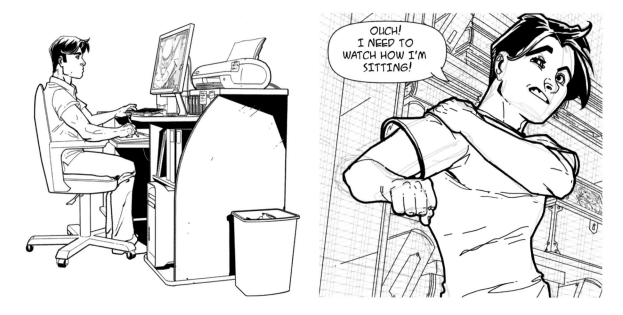

Left: A general rule of thumb, ergonomically, is to keep your back straight and your knees bent at a 90-degree angle as much as possible.
Right: Even comic book characters get sore when they don't pay attention to ergonomics. This panel comes from *Robin #152.*

while drawing can cause short-term inflammation and long-term pain. Eventually it might even lead to carpal tunnel syndrome, which is disabling and may require surgery to correct.

You need to find a way of sitting that feels comfortable for you and prevents slouching. This isn't just a matter of the computer desk, computer chair, and monitor you have but also of their positions relative to each other.

It's equally important for your monitor to be at eye level so that you are not craning your neck to look up or down at it, which can cause headaches and shoulder strain. A good friend of mine had to stop drawing for more than a year because of severe neck pain caused by the odd angle he sat at when drawing.

MONITOR CALIBRATION

One way to reduce eyestrain is to calibrate your monitor for color and sharpness. Ever notice that the same image can look dramatically different on two different monitors? That's because they are calibrated differently—or, more likely, have never been calibrated at all. For a colorist, color calibration is vitally important; it's less important if you are producing primarily black and white art, in which case it's the contrast of the screen that is crucial. Making sure that your whites look completely white and your blacks are a deep, solid black both reduces eye strain and enables your to create clean line art. Before attempting to calibrate your monitor for color or contrast, it's best to consult the documentation that came with it. If the documentation doesn't yield many clues, there are standard calibration options for both Mac and PC systems.

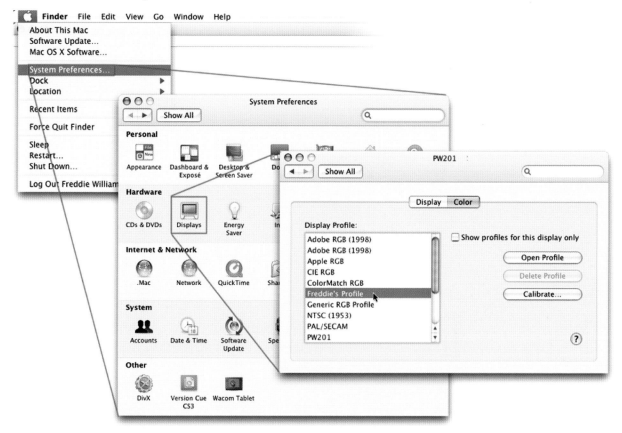

To customize color settings on a Mac, go to Apple Menu > System Preferences > Displays. As you can see from this screenshot, I've made a custom color profile for my computer.

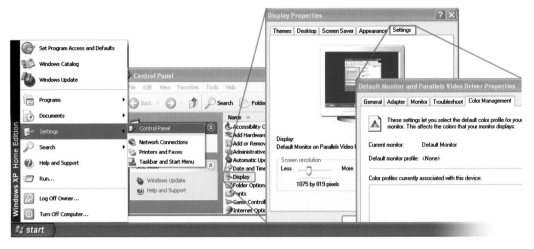

On a PC, go to Start Menu > Settings > Control Panel > Display > Settings > Color Management.

CUSTOMIZING WACOM SETTINGS

Many people don't take the time to customize the settings of their Wacom tablets, but adjusting firmness and the button configurations can be quite helpful, so you should be aware of how to do so. You can assign keystrokes to different buttons on the stylus itself—or disable them entirely. I suggest you play around with these settings. Adjustments can make the Wacom more user-friendly, help you finesse the look of "pressure sensitive" lines, and save you time in the long run.

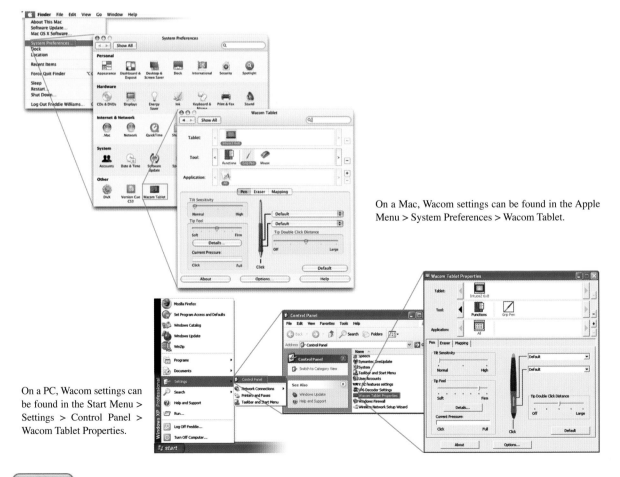

On a Mac, Wacom settings can be found in the Apple Menu > System Preferences > Wacom Tablet.

On a PC, Wacom settings can be found in the Start Menu > Settings > Control Panel > Wacom Tablet Properties.

An underutilized, often overlooked preference in the Wacom tablet settings allows you to "map" the Wacom to your screen. The default Wacom setting maps the four corners of the live area of your Wacom to the four corners of your monitor's screen. But I prefer to adjust the mapping to cover a smaller area on my Wacom tablet. With a smaller mapped area, the fluid movements of your wrist or hand pay off big on your screen. Sketching smaller also adds more life to your figures and keeps your energy up.

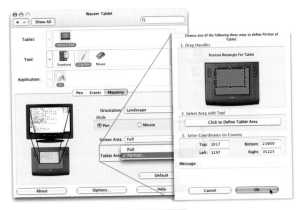

Here is where you'll find the setting to "map" your Wacom tablet to a different portion of the screen.

BACKING UP

There are three rules you've got to remember: (1) back up, (2) back up, and (3) back up! As you come to depend more and more on digital files, the risk of a hard-drive failure or of computer viruses wiping out all your work becomes unbearable. Doing regular backups is essential to protect against these and other threats, so I recommend you create a backup protocol similar to the one I use.

My extremely redundant, failsafe system of backing up data may seem excessive to some, but it has come in handy on more than one occasion. Usually, you can copy files or burn backup disks at the same time you are working on other things, though I do try not to overtax my computer while making backups, usually sticking to answering email or other, less CPU-taxing activities. An added benefit of my method of backing up is that it's easy to carry along DVD backups when I travel.

Having an off-site backup is a good idea, too. In the event your house burns down or floods, you'll still have all your files!

Every night I back up that day's work on one of my external hard drives. I consider this a "living" primary backup. (It's called a "living" backup because I'm still adding to and updating these files and project folders.)

After completing an entire comic book issue, I burn that comic to a single-layer DVD as a secondary backup.

When I've finished six issues of work, I burn all the files for those issues to a dual-layer DVD as a tertiary backup.

Every month or two, I back up my entire "living backup" external hard drive onto another external hard drive of equal size, which is my final backup.

GETTING STARTED IN PHOTOSHOP

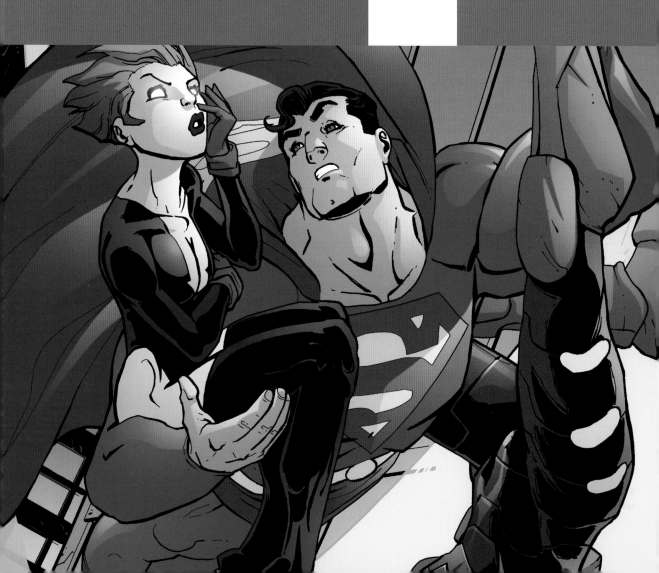

Although this book is targeted at intermediate or advanced users of Adobe Photoshop, I'd like to take a moment to familiarize you with the workspace and the palettes I primarily use. (*Workspace* just means the location of the palettes and toolbars of your working environment in Photoshop.)

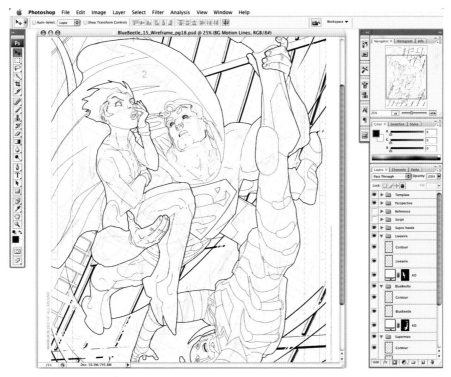

This screenshot above shows Photoshop's default palettes at the right. The image on screen is from page 18 of *Blue Beetle* #15, as is the final inked and colored image opposite (colors by Guy Major).

When you first install Adobe Photoshop, an array of default palettes appears along the right-hand side of the screen. Over the last few years, I have customized my workspace, reducing the number of palettes and streamlining them down to the essentials. Palettes like Navigator, Colors, Swatches, and Histogram aren't of much use to me, so I've closed them out and made room for the palettes that I'm always using. It's a good thing, too, because at the rate I accumulate layers, I need a lot of screen space.

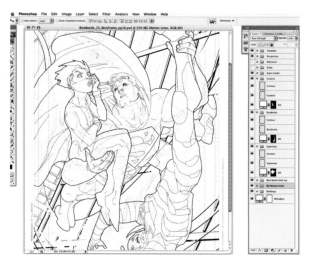

I recommend that you continue to customize your own workspace as you work. Your work in Photoshop will go more smoothly if every tool is exactly where you want it to be. When you've created a workspace that feels right for you, save that workspace so you can call it up in the event someone else uses your computer and changes it (or you mess things up yourself). You can save your palette locations and custom keyboard shortcuts by going to Window > Workspace > Save Workspace.

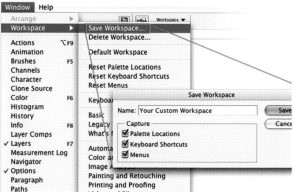

This is the standard palette location I use when working. All the palettes I've removed from my workspace can still be found under the Window menu at the top of the screen.

Now, let's look at the palettes I use in my own customized workspace. Palettes can be grouped together in a single window and then accessed through collapsible tabs at the top of those palettes.

First up are three palettes that are grouped together in Photoshop: Layers, Channels, and Paths. Since they are by far the most commonly used palettes, it makes sense to keep this default grouping.

LAYERS PALETTE

The Layers palette allows you to break your drawing into many different layers. (Layers are the digital equivalent of drawing on multiple sheets of clear vellum or celluloid.) The palette permits easy adjustments and enables you to reuse or to easily delete certain elements from the layers. With Layers, you can alter parts of your drawing without messing with any other elements on the page. Using Layers cuts back on redrawing and cleanup time.

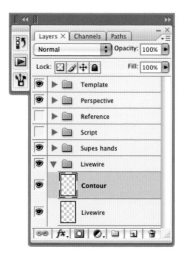

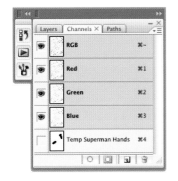

For RGB images, the Channels palette displays Red, Green, and Blue channels as well as the composite RGB channel. Any of the Alpha channels we create will appear under those RGB channels.

The file format we'll be working with most often in this digital workflow is RGB mode. If you open an RGB image and display the Channels palette, you will see the Red, Green, and Blue channels, plus an RGB channel, which is a composite of the three channels. The R (Red), G (Green), and B (Blue) channels come together to create a full-color image: All the colors you see in an RGB file are a combination of grayscale information in each of the R, G, and B channels. (To gain an understanding of what that means, click on an individual channel, and you'll see the grayscale values that the channel contains.)

The RGB channels can be a little confusing, but luckily we won't be messing with any of them—only with the channels we ourselves create, which Photoshop calls Alpha Channels. Alpha Channels are akin to the traditional cut-out "shields" or Frisket masks (to use some traditional airbrushing terms), which isolate areas of a painting you would like to paint with an airbrush.

Alpha Channels are mostly used when you'd like to save a complex selection you've made with the freeform Lasso tool so that you don't have to recreate it later. We'll talk about using the freeform Lasso tool in later chapters.

Although I'll get into more specifics about Channels later, I just want to take a sec to note that when you make any additional Alpha Channels, make sure the Selected Areas option is clicked; this will help avoid confusion later on.

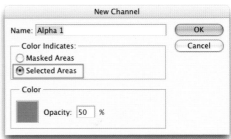

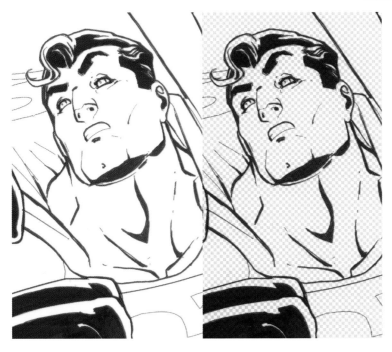

There is also a useful technique, using Alpha Channels, that allows you to take line art or textures that have been scanned in or drawn on a white background and convert them to line art on a transparent background. (I describe this technique and its uses in more detail in chapter 7.)

PATHS PALETTE

Paths are primarily used in vector art programs like Adobe Illustrator to create flat graphic art (logos, for example). In Adobe Photoshop, paths work like stencils or French curves.

Creating and reusing customized paths for cityscapes, chest symbols, and logos is essential for keeping the look of these elements consistent and accurate. We'll explore them extensively in chapters 6 and 8.

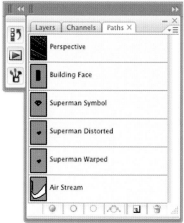

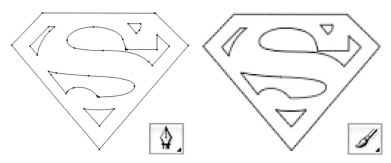

On first glance, the Paths palette is the most confusing of the three options in this group. Don't let this intimidate you, though; they are easy to get a handle on.

(Right) Paths are great for super heroes' chest symbols, because they can be resized and distorted without losing resolution.

When you create a path, you are making something akin to a customized stencil. The paths themselves, created by using the Pen tool, (above left) don't make a printable line until the Pencil or Brush tool is applied by "stroking" that path onto a layer (above right).

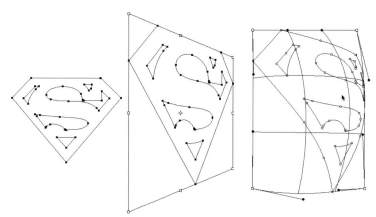

BRUSHES PALETTE

Adobe Photoshop comes with plenty of default brushes, and each one can be customized with a dizzying array of options. You should take the time to experiment with all the default brushes, as well as with making brand-new, customized brushes (covered in chapter 7). If you create and use them right, they can create what look like meticulously drawn energy signatures, rock patterns, leaf formations, and background effects with little time and effort.

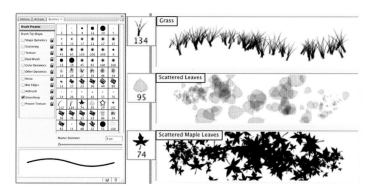

Notable Photoshop default brushes include these cool leaf and grass brushes. You can use these to great effect in middle-distance or far shots. (They are less effective when the shot is closer to the "camera.")

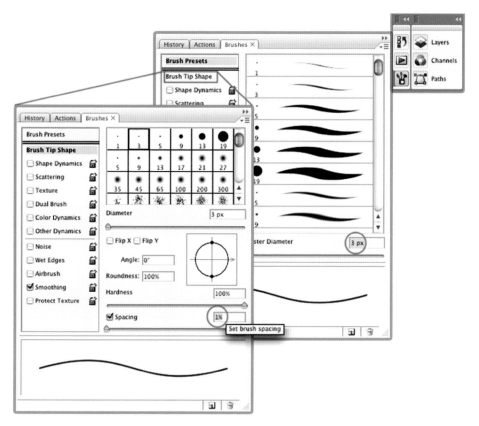

When working on roughs and "wireframes," I use either a 3-pixel or 4-pixel, with no shape dynamics; for the brush tip shape, I use the maximum hardness and minimum spacing settings. Note that the 3-pixel brush is among the preset brushes offered on the menu, but you can actually choose whatever size brush you want by typing the number of pixels into the Diameter box or by moving the slider.

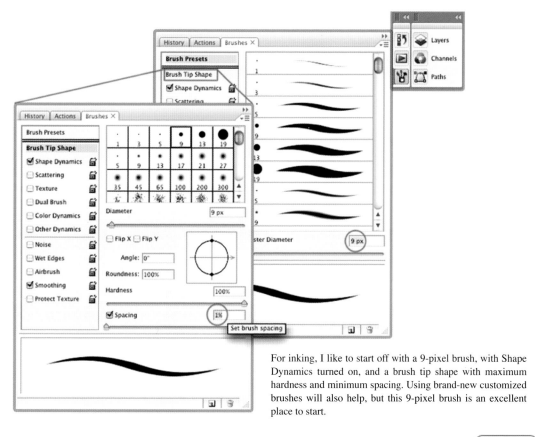

For inking, I like to start off with a 9-pixel brush, with Shape Dynamics turned on, and a brush tip shape with maximum hardness and minimum spacing. Using brand-new customized brushes will also help, but this 9-pixel brush is an excellent place to start.

HISTORY PALETTE

Everything you do in Adobe Photoshop is recorded as a "history state" located in the History palette. You can adjust how many history states you would like Photoshop to store in the History palette by going to Performance preferences, at Photoshop > Preferences > Performance. Photoshop can store up to a staggering one thousand history states. Be careful, however: The more history states Photoshop stores, the more cache memory they take up on your computer. If you are low on RAM and working on large files with a big number of history states, your computer can slow down or possibly even crash. I generally stick to around fifty history states.

Using the History palette is like time travel: The palette lets you go back in time to undo any mistake you might have made earlier.

ACTIONS PALETTE

The Actions palette will become one of your best friends. It allows you to automate most repetitive tasks, such as resizing pages and saving them out as JPEGs to email to your editor for approval. Along with Paths, the Actions palette is the most powerful tool in my digital workflow, mostly because of the time actions save. (I discuss creating and using actions in detail in chapter 7.)

These screenshots show examples of the arsenal of actions I've created and collected over the years; they simplify tasks and make my job easier.

GETTING FAMILIAR WITH PHOTOSHOP

The best way to get more familiar with Adobe Photoshop—or with any computer program—is just to get in there and play around. I learned many of the computer programs I use today mostly through trial and error. Try not to have too-high expectations when experimenting with tools you're unfamiliar with, however. And don't be afraid that you'll break something: Thanks especially to Photoshop's history function, you can undo quite a bit. Remember, too, that you can save many different versions of a file as you are working on it, trying out different ideas or approaches on different layers. If you take baby steps and don't expect to attain perfection immediately, you'll end up finding your own way with the tools and methods discussed in this book.

5

DIGITAL AND HYBRID WORKFLOWS

In the chapters that follow, I go into depth about the various steps in digital as well as hybrid workflows. (The two hybrid workflows both use a mix of digital and traditional methods.) In this chapter, though, I'm going to lay out the basics of the three different workflows and make comparisons between traditional working tools and the digital tools you'll be using in Adobe Photoshop.

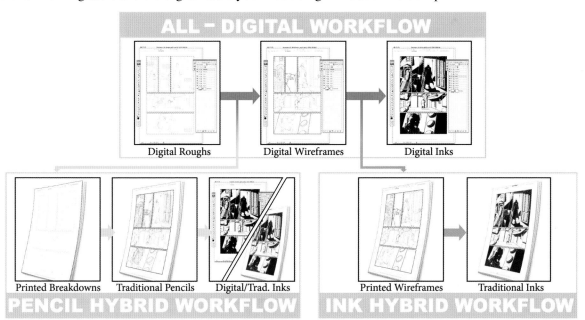

The three workflows described in this chapter all start in the same way but then go off in their own directions. You may find it helpful to refer to this diagram as you read my descriptions of the three workflows. The artwork above is from *Outsiders* #45. The art opposite is from page 2 of *Outsiders: Five of a Kind—Nightwing/Boomerang* (colors by Guy Major).

When I was working in the traditional paper-and-pencil way, it would take me about seventeen hours to complete a page, from roughs to inks. Now, working digitally, it takes me eight or nine hours to go from rough to inks. That's nearly half the time! I can't guarantee that you will save that much time yourself, but I'm confident that once you get comfortable with working digitally—whether entirely digitally or using one of the hybrid methods—you *will* save time. Just imagine: No more lightboxing, and a tremendous reduction in time spent on cleanup and scanning.

Each of the three working methods I've created—the All-Digital Workflow, the Pencil Hybrid Workflow, and the Ink Hybrid Workflow—relies heavily on digital tools. In what follows, I list every step for each workflow, even when some of those steps are also explained in the other workflows, so you can clearly see where each step falls. I recommend that you give each method a try to see which works best for you.

ALL-DIGITAL WORKFLOW

In this method, you keep all the art in the computer. This is the workflow I use the vast majority of the time because it's the fastest and most streamlined of the three systems. I ink my own work, so I utilize the time-saving devices Adobe Photoshop offers all the way through the process from beginning to end.

When working in the All-Digital Workflow, I use actions to save each of the following steps as a separate file (one for roughs, another for wireframes, and another for inks) so that if something goes awry at any stage in the process, I can always go back to the last major step. One big advantage of this workflow is that you're using only one tool (the computer) as opposed to the myriad of pencils, erasers, quills, brushes, and other tools that you might need in the traditional method.

STEP 1: DIGITAL ROUGHS

Using a Wacom tablet or Cintiq, I sketch out the flow of the page in my Master Page Template, all in Photoshop. When it comes time to hand these in to my editor, there's no need to scan, as there would be with a traditional rough layout drawn on paper. (I describe the Master Page Template in chapter 6 and explain how to draw roughs digitally in chapter 8.)

I can email digital roughs like these (from *Outsiders* #45) directly to my editor for approval.

STEP 2: DIGITAL WIREFRAMES

Many artists (myself included) have the instinct to jump ahead to the rendering step without making sure that the drawing's underlying structure is as solid as it can be. The wireframe step keeps me honest with regard to anatomy and structure.

I call these second-stage drawings wireframes because they are devoid of lighting or rendering. They're usually drawn with a 3-pixel brush throughout, giving them a nice, clean line. This stage is the equivalent of tight or final pencils in the traditional pencil-and-paper method of working.

In this stage I also add a "dead" contour line around figures to help define their shapes in relation to the other elements on the page and to get a jump start on the digital inks. (Wireframes are described thoroughly in chapter 9.)

STEP 3: DIGITAL INKS

Because the wireframes have clean black structure lines, with the contour lines already in place and some of the inks (especially on backgrounds) already essentially done, you have a huge head start on the inking. Now you can jump directly to adding texture, rendering, and shadows and finessing the line weights to finish off the page.

When inking digitally, it's very easy to make corrections up until the moment the page is done. Moreover, all corrections are clean: There is no perceivable difference in line quality when you layer black inked lines and white corrective lines on top of each other, over and over (as opposed to the poor results you can sometimes get when applying Wite-Out to cover mistakes). Digital inking really gives you the kind of finished inks you want. (Digital inks are explained further in chapter 11.)

PENCIL HYBRID WORKFLOW

This method is for pencillers who would like to have a physical piece of art at the end of their workflow, either because they want originals that they can sell or because an editor asks them for pencilled art that can be sent on to an inker who is working traditionally.

This is the workflow I recommend to pencillers who are just starting to move into the digital world. The opening steps in the Pencil Hybrid Workflow replace the traditional steps of roughing out the page on printer paper, blowing up the rough on a copier, and lightboxing the layout onto bristol board. This method, however, lets you accomplish these steps faster and more precisely.

STEP 1: DIGITAL ROUGHS

In the Pencil Hybrid Workflow, you do the digital roughs just as you did them in step 1 of the All-Digital Workflow.

STEP 2: DIGITAL BREAKDOWNS

As with traditional pencil-and-paper breakdowns, digital breakdowns are a little tighter than roughs. When creating digital breakdowns, it's a good idea to lay out a digital perspective grid for each panel that needs one in the breakdown stage. This will save you time in the pencilling stage. (Digital perspective grids are described in chapter 9, and I explain breakdowns further in chapter 10.)

STEP 3: PRINTING THE BREAKDOWNS

This step takes the place of all that tedious lightboxing in the traditional pencil-and-paper workflow. Print the digital breakdowns onto bristol board in light non-photo blue. Make sure the print is dark enough for you to see all the lines you drew in the digital breakdowns but still light enough that they will not be very noticeable when you pencil on top of them and will be easy to eliminate if the pencils are going direct to color.

STEP 4: TRADITIONAL PENCILS

With this step, we return to the traditional pencil-and-paper workflow. But there's a difference: Because this is the first time you are touching the bristol board, the paper will not have absorbed any hand oils and will therefore be cleaner than in the traditional workflow. This means the paper will be in better shape for any collector who buys your original art, or for a traditional inker down the line. Cleaner pages also make for better results if your pages are going direct from pencil to color. You should pencil normally, directly on top of the light blue breakdowns.

STEP 5: DIGITAL OR TRADITIONAL INKS

The Pencil Hybrid Workflow offers artists who want to produce a physical piece of art on bristol board a more consistently exact and better-thought-out approach to composition, with a cleaner end result. After the traditional pencils have been finished, they can be inked digitally or in the traditional manner.

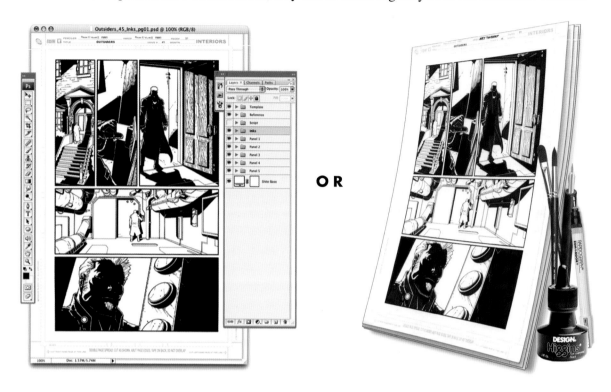

OR

INK HYBRID WORKFLOW

The Ink Hybrid Workflow is for artists who would like to set up their page layout and work out the tight structure of their page digitally but would still like a physical piece of art at the end of the process, either because they like the tactile interface of the paper with traditional inking or because they want original pages to sell.

STEP 1: DIGITAL ROUGHS

In the ink hybrid workflow, just as in the pervious two workflows, we create all-digital roughs as the first step.

STEP 2: DIGITAL WIREFRAMES

Create wireframes the same way you do in the all-digital work-flows. In the Ink Hybrid Workflow, the wireframe drawing takes the place of the pencilling step.

The only difference between the Ink Hybrid version wireframe and the all-digital wireframe is that the "dead" contour line around elements (primarily figures) should be drawn thinner. That way, when you are inking the page in the traditional manner, the printed black line art will be a little more open to being adjusted.

STEP 3: PRINTING

Print the digital wireframes on Bristol board in black ink. If you have a high-end large-format printer, you can print the wireframes in the comfort of your own studio. If not, you'll have to go to a copy shop that can produce a rich black line (possibly on a plotter machine). But however you get the wireframes printed, make sure that the print is as dense and as rich a black as possible, because those wireframe structure lines will be part of the inks. (This is all explained in greater detail in chapter 11.)

STEP 4: TRADITIONAL INKS

On the printed art board, use traditional inking tools to finish ink-ing the rest of the page; add texture, rendering, and shadows; and finesse the line weights. (Since the lines printed on the bristol board from the wireframe drawing are already black, some of the inks—especially on backgrounds—are already done.)

With nearly every issue I work on, deadline permitting, I pick out two or three pages that I think will sell well and work on them using the Ink Hybrid Workflow. If you decide to do this, you must make the pages that are completed in the Ink Hybrid Workflow look consistent with the all-digital pages, so that there's no noticeable difference between them when the comic book is printed. I do this by scanning the inked page at a high resolution and then cleaning up the scan to make sure the line quality meshes well with the rest of the digitally drawn book.

A WARNING ABOUT DISTORTION

All scanners and printers have distortion factors, and they differ from device to device. If you draw a perfect square, each of whose edges perfectly parallel the edges of the paper it's drawn on, and then you scan that drawing into the computer and look at it really closely, you'll see that the square has become slightly less perfect. The top may now seem slightly wider or taller than the original. If you then print out the square, it will warp even further. Rescan that printout and the square will warp still further. It's the same phenomenon that happens when you make a photocopy of a photocopy of a photocopy, except that the distortion here is only about half as bad with each step (scanning or printing).

Because both of the hybrid methods require printing and scanning, your art may not match up perfectly with your wireframe or breakdown drawings. To correct for this, I bring the scanned art into the wireframe or breakdown drawing and make it match up again using a process I will cover in detail in chapters 9, 10, and 11.

As we can see here, when a drawing of a perfect square goes through a repeated cycle of printing and scanning, it degrades, distorting the original shape.

DIGITAL WORKFLOW EXERCISE

This exercise is designed to show you how powerful Adobe Photoshop can be and to make you more comfortable working with its tools. We'll begin by drawing a bust shot (head and shoulders) of one of your favorite characters. Remember, this doesn't have to be perfect, but it'll be good to get your feet wet with an all-digital piece of art.

STEP 1: CREATE A DOCUMENT

Create a new document in Adobe Photoshop by going to File > New, clicking on the drop-down menu next to Preset, and choosing the U.S. Paper preset, which will give you a document measuring 8½ x 11, with a resolution of 300 pixels per inch, in RGB color mode. Name the file "DigitalWork-flowExercise," and save it on your hard drive. The U.S. Paper preset will give you the right dimensions and resolution, although sometimes, depending on the settings used for your previous Photoshop document, it may default to grayscale mode—so make sure the document is in RGB mode.

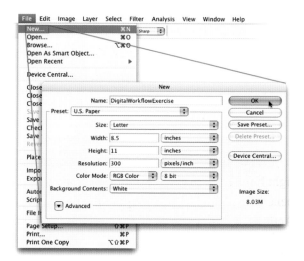

STEP 2: CHOOSE A BRUSH

In the Brushes palette, choose a hard-edge 3-pixel brush with no shape dynamics. Click on Brush Tip Shape and choose a brush with maximum hardness and minimum spacing. These are the brush settings I usually use when drawing my roughs and wireframes.

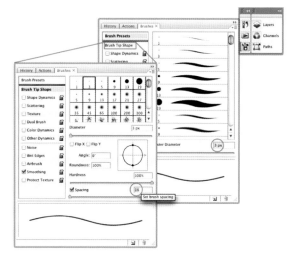

STEP 3: BEGIN THE ROUGH

In your Photoshop document, create a new layer called "Roughs," and rough out a very simple, very blocky bust shot. At this stage, you are just establishing the space and overall shape of the sketch.

You should get into the habit of naming every new layer that you create. At first this may seem like a waste of time, but it will come in handy if you are switching between batches of several pages, as I often do. Unnamed layers can rapidly make things very confusing.

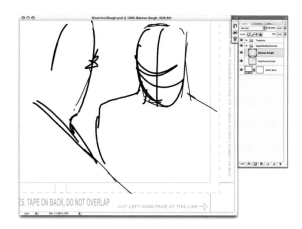

The rough shown here is for a panel I drew for *Outsiders: Five of a Kind—Nightwing/Boomerang*.

STEP 4: CREATE A HUE/SATURATION LAYER

After you've roughed out the blocky shapes of the face and shoulders, create a Hue/Saturation adjustment layer. Start by going to Layer > New Adjustment Layer > Hue/Saturation. In the Hue/Saturation dialog box that appears, check the Colorize box and set these values:

Hue: 200 Saturation: 60 Lightness: +75

These settings will turn your line work into a light blue that mimics the color of a non-photo blue pencil. In chapter 7, I show you how to record an Action for this step so that you can call it up at the touch of a button.

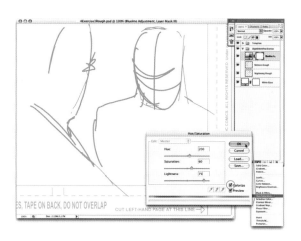

Creating a Hue/Saturation adjustment layer like this is a staple of all three workflows.

STEP 5: TIGHTEN UP THE ROUGH

On top of the Hue/Saturation layer, create a new layer called "Breakdowns." On this layer, tighten up the rough structure of the drawing using the Brush tool (set at the same hard-edge 3-pixel settings).

While you are sketching, if something isn't feeling right, try turning off the layer you're in (by clicking the "eyeball" icon in the Layers palette for the appropriate layer), then create a new layer and sketch something else.

Repeat this step as many times as you need to, stacking Hue/Saturation layers on top of the previous sketch layers. Each time you add a layer, tighten up the structure a little more. These sketch layers will not be permanent—you are using them just to get to a clean structure drawing, so there's no need to give names to these intermediate temporary layers. Each new Hue/Saturation layer will make the drawings on lower layers lighter. They're still visible, but they don't distract you from whatever you are currently tightening up.

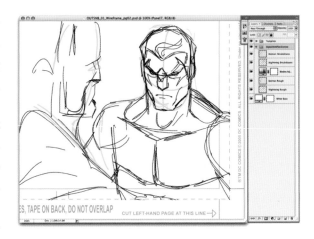

Creating a new Breakdown layer over the light-blue rough allows you to tighten up the structure.

STEP 6: CREATE A WIREFRAME

After you have your Breakdowns sketch to a point where it looks and feels right, create another Hue/Saturation adjustment layer, then a new layer, called Wireframes, on top of that. Now, using a hard-edge 3-pixel brush, draw over your breakdown sketch with clean, precise, final lines, devoid of shadow or rendering.

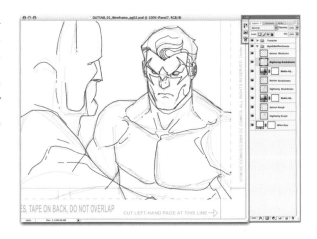

The goal of the wireframe stage is to make the structure as solid as you can.

STEP 7: MAKE A CONTOUR OUTLINE

After you are finished with the tight wireframe structure drawing, create a new layer called "Contour." Contour outlines further define the drawing's major shapes, enhancing the silhouette of the outlined element. Using a larger brush, draw contour outlines around the edges of the characters. I usually draw my contour outlines with a 6- or 8-pixel brush, though you should feel free to make your contour outline as thick or thin as you like—as determined by your own style.

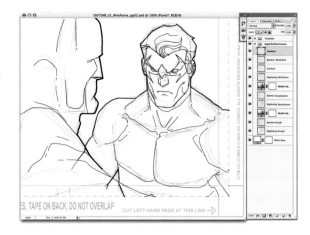

STEP 8: FINALIZE THE WIREFRAME

Once you've created the thicker, contour outlines, turn off (or, if you wish, delete) all the structure/gesture/rough/breakdown layers you used to get to this point, leaving only a clean, open wireframe drawing.

You've just created your first wireframe drawing! Now it's time to ink overtop your wireframes.

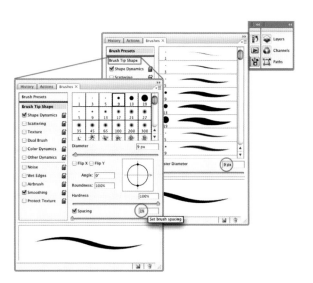

STEP 9: CHOOSE A BRUSH FOR INKING

Before proceeding to inks, you've got to change your brush settings. In the Brushes palette, choose a 9-pixel brush, with Shape Dynamics turned on and a brush tip size set to maximum hardness and minimum spacing. These settings will produce a traditional-looking brush line that works well for digital inking. Turning on Shape Dynamics allows you to create a line that grows thicker or thinner depending on how hard you press using your Wacom stylus.

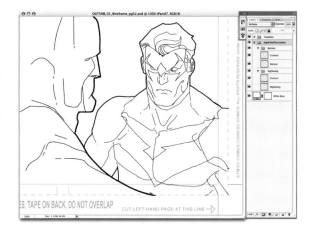

STEP 10: BEGIN INKING

Above the Contour layer, create a new layer called "Inks," and start experimenting with your pressure-sensitive brush. The goal is to emulate the traditional inked look. Line variance is our friend here, because the more line variance there is, the more traditional the inks will appear. Using a brush with Shape Dynamics turned on while inking will help give a traditional brush or quill look to the inks.

STEP 11: FILL IN THE SPOT BLACKS

When filling in large black areas—the spot blacks—try using the freeform Lasso tool to outline the shape of the area you want to ink, then fill it with black by going to Edit > Fill. I've found that inking with the Lasso can give a more organic feel to the end result.

To get organic-looking shapes when inking, I often set the Lasso tool to a feathering of 0, making sure the Anti-alias box is checked.

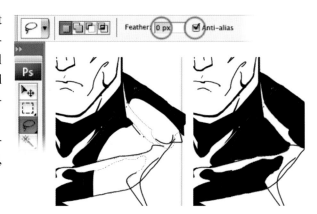

STEP 12: FINALIZE THE INKS

Do one final pass over the image, making sure all the inks are finessed. You can touch up any rough edges using your Brush tool set to white (which is also a good way to create hair textures).

Congratulations! You've just created your very own 100-percent digital comic book illustration!

Tah-dah! The final inked piece!

SOME NOTES ON FILE HANDLING
AND WORKING METHOD

Because I work in an almost assembly-line way, I always try to err on the side of caution. I break the three steps—roughs, wireframes, and inks—into three different files so that in a worst-case scenario I can always default to the previous incarnation of the page, which has saved me on more than one occasion. And there's another advantage to breaking up the files in this way: Sometimes my editor wants to see the wireframe stage before I move on to the inks stage, and breaking up the files makes the different versions easier to track.

After I read a script, I create a schedule for myself. The deadline determines how many weeks I have to finish the book, and thus how many pages I need to finish per week—usually six or seven.

On the first day of each week, I complete all the roughs for each of the pages I've budgeted for that week. Over the next couple days, my goal is to create two to three pages of wireframes a day until I've gone through all the roughs. Finally, I ink three to four pages a day until I've finished all the pages I set out to complete that week.

I generally work in batches of six or seven pages at a time (sometimes more). I've found that leaving a page alone for a day or two while working on other pages in the same stage of development allows me to come back to that page with a fresher eye and keeps my energy high.

THE MASTER PAGE

6

CREATING THE MASTER PAGE
TEMPLATE: A STEP-BY-STEP GUIDE

On my website, www.freddieart.com, in the "Digi-Art QuickTools" section, I offer a generic comic book page template that is good for a typical 11 x 17 art board. Even so, this chapter will be very useful as an exercise to get you more familiar with the tools in Adobe Photoshop, as well as to make sure that your Master Page Template matches your particular publisher's specifications.

It's very important to create a Master Page Template that corresponds to the publisher's guidelines in size, bleed, and trim area. This will take a few hours, but if you do it right the first time, you'll never have to do it again.

When I got my first assignment from DC Comics, the company sent me a stack of blue-lined art boards with DC's unique template printed on them. I wanted the pages I drew digitally to exactly match DC's specifications, with the same size bleed, live area, and trim, so the first thing I did was create a Master Page Template based on DC's official art board. The few hours I spent on this have saved me an incalculable amount of time ever since—because once it's done, it's done!

The artwork opposite is from page 13 of *Robin* #178 (colors by Guy Major).

STEP 1: SCAN THE ART BOARD

Scan the comic art board you want to use as the basis for your digital Master Page Template. Ideally, you should scan the lined and ruled board on a large-format (11 x 17 or larger) flatbed scanner. Scan the board at 300 dpi, in color, in RGB mode. If you don't have a large-format scanner, you will either have to scan the board in two halves and then splice them together in Photoshop or make a color photocopy of the board, reducing it to letter size (8½ x 11) and scanning in the copy. If you use a color photocopy, you'll then have to increase the size in Photoshop to match the board's original size (which you can do at Image > Image Size). The resolution won't be the greatest, but don't worry about that, because this initial scan is done just for positioning the ruled lines. Ultimately, you'll be recreating the entire template digitally.

If the scan is light, you may want to darken it using the Levels dialog box at Image > Adjustments > Levels. In the Levels dialog popup, just below the histogram chart (the graph that shows the levels of dark and light pixels), are black, gray, and white upward-pointing triangles; these are the Levels sliders and can be moved left and right to adjust tones in the image. Pulling the black one to the right will darken the blacks in the image, while pulling the gray one to the right will darken the image's midtones. Feel free to play around in the Levels dialog box to figure out how everything works.

STEP 2: NAME AND SAVE THE SCAN

Once you have the scanned template in Photoshop and you've darkened it enough to see all the ruled lines, rename this layer as "Raw Scan." This is a good time to save your document. It's a good idea to get into the habit of saving after every step or two, just in case Photoshop (or your computer) crashes, or the power goes out, or you accidentally hit the power strip switch with your foot (which I have done).

Don't worry about any smudges or digital dirt on the raw scan; again, this scan is just going to be used as the basis for you to build your own digital template.

STEP 3: DUPLICATE THE RAW SCAN

Duplicate the Raw Scan layer by going to Layer
> Duplicate Layer. Name the duplicated layer
"Aligned Template Base." For now, let's keep the
Raw Scan layer, so that you can come back to the
raw scan and start again in case something goes
wrong.

We will use the Aligned Template Base layer
to make all of the guides and rules parallel with the
sides of the Photoshop document, to create a base
for the final page template.

Here's the Duplicate Layer dialog box.

STEP 4: CREATE THE GUIDES

To create guides, you'll need to see the rulers at the
top and left sides of your screen. If they are not al-
ready visible, go to View > Rulers. Then click in
the upper ruler area and drag down to create hori-
zontal guides, or click in the left ruler area and drag
right to create vertical guides. Try to align the Pho-
toshop guides with the ruled lines in the scan as
closely as possible. Most likely, the scanned lines
will not exactly match the guides, because the scan
will be slightly distorted. Drag Photoshop guides to
the two vertical and two horizontal trim and bleed
lines. These guides will give you a good reference
to get your Aligned Template Base layer set up and
aligned over the next few steps.

Guides, which won't show up on the printed page, are a useful tool
for keeping vertical and horizontal lines parallel to the edges of your
Photoshop document.

STEP 5: CORRECT ALIGNMENTS AND DIMENSIONS

Now it's time to *exactly* line up the scanned art
board lines with the Photoshop guides.

First, draw a selection box just inside the edges
of your file, using the Rectangular Marquee tool.
Then go to Edit > Transform > Distort. This function
will allow you to shift the scan around to match it up
to the Photoshop guides we just created.

Using the squares in all four corners of the
bounding box, shift the scan around until the scanned
lines align with the Photoshop guides.

Next, using the Photoshop rulers, double check to make sure that the Aligned Template Base layer is the correct height and width by measuring the art board you scanned and comparing it to the rulers in Photoshop. You may need to do some additional scaling with Edit > Free Transform to get your scan to the exact same measurements as your ruled art board. You can always reposition your guides by holding down the command key (on a Mac) or the control key (on a PC) and dragging the guides to where the scanned lines may have shifted during the last scaling of the layer. Once all the scanned lines match the Photoshop ruler lines, the scan is correctly aligned and sized. When the Aligned Template Base layer exactly matches the size of the art board, feel free to hide your rulers again (under View > Rulers). I advise you to keep any guides you create, as they will help you in later stages.

STEP 6: CREATE THE FINAL TEMPLATE LAYER

Create a new layer on top of the Aligned Template Base layer and name it "Final Template," then set this new layer to Multiply mode. This is the layer for the final, clean, precisely ruled lines. Using the Brush, vector Rectangle, and Text tools, recreate the printed lines and text of the scanned art board.

If you use any of the Vector or Path tools in the Paths palette, you will need to stroke or fill the path for the lines so that they will show up on the layer and be printable. The Text tool is needed for the information at the top of the page that publishers sometimes add to their art boards.

If you are working from a publisher's art board, don't feel obligated to recreate logos or other inessential information on the physical art board. The most important parts of the template are the trim and bleed lines and the textual information at the top: the publisher, the name of the book, the issue number, and the penciller and the inker. Filling in this information will help you to keep the pages in order.

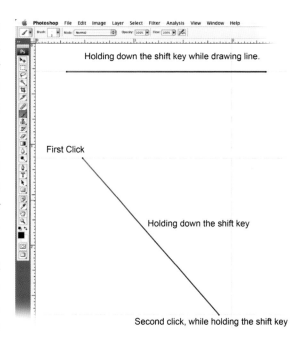

To draw a ruler-straight line parallel with any of the edges of the document, use the Brush tool and hold down the shift key while drawing. To draw a ruler-straight diagonal line with the Brush tool, click where you want the line to begin, then hold down the shift key and click where you want the line to end.

STEP 7: CREATE A SOLID COLOR FILL LAYER

After you've recreated the template on the Final Template layer, create a Solid Color Fill layer by going to Layer > New Fill Layer > Solid Color. In the dialog box, name this layer "White Base." Then, in the Adobe Color Picker box that now appears, drag the color selector all the way to the top left; this is pure white. Then drag your new Solid

The Solid Color Fill layer is found at the bottom of the Layers palette.

Color Fill layer under the Final Template layer in the Layers palette.

This solid White Base layer will block out all the layers under it, allowing you to see whether you have recreated the template correctly. To make sure you haven't missed anything, click the "eyeball" icon in the Layers palette off and on.

By the way, I recommend using Solid Color Fill layers whenever you want a large area to be the same flat, solid color. It keeps the file size small, and, if you choose to, you can change its color very easily by double-clicking on the left icon for the layer in the Layers palette and selecting a new color for that solid color fill.

When you've made sure that the entire template is correct, you can delete the Aligned Template Base and Raw Scan layers. You won't be needing them again.

STEP 8: PUT THE TEMPLATE IN A LAYER GROUP

Take a moment to create a new layer group and to place your template in it.

Go to Layer > New > Layer Group; name the new layer group "Template." Put your Final Template layer inside this layer group. Everything that's related to the template will be kept in the Template layer group—which will help you stay organized. Layer groups are like folders for storing and organizing layers inside a Photoshop file.

You now have a clean, precise, finalized template on a transparent layer by itself (not surrounded by white pixels), and you've completed the lion's share of work on your Master Page Template.

STEP 9: CONVERT THE TEMPLATE TO LIGHT BLUE

Select your new Final Template layer inside of the Template layer group and convert it to light blue by going to Image > Adjustment > Hue/Saturation. In the Hue/Saturation dialog box, check the Colorize box, then set these values:

Hue: 200 Saturation: 60 Lightness: +75.

This will turn all the template lines to a light blue that mimics the non-photo blue we all know and love. When converted to light blue, your template will resemble an art-board template printed in non-photo blue.

STEP 10: DEFINE THE TRIM AREA AND MAT

Using the Rectangle Marquee tool, select the area of the template that's inside the trim area. On DC's art boards, this area is bordered by a dotted line and is identified on the template as the trim area. Other art board templates may differ slightly, although most art boards with templates on them designate the trim. The Rectangular Marquee tool creates rectangles at exact right angles to the corners of the Photoshop document.

STEP 11: CREATE A MAT

Once you have selected everything inside the trim area, invert the selection (to select everything outside the trim area) by going to Select > Inverse.

When you make a Solid Color Fill layer while a selection is active, the Solid Color Fill layer will be in the shape of that selection.

Now that you have the trim area selected, create another Solid Color Fill layer, set it to white, and name it "Mat." Place this new layer under your Final Template layer. The Mat layer will mask any art drawn on the layers underneath it. I find it useful in helping me to visualize the page, since the area it covers will be cut away in the printing process.

STEP 12: FINISH THE TEMPLATE LAYER GROUP

To finish up your Template Layer Group, use the Text tool to add your name to the credits section on the Pencils line or on both the Pencils and the Inks lines if you are doing both. This will spare you from having to manually add this information to every page you work on. Create "dummy text" on the lines for the name of the book, the issue, and the page number; these are just placeholders that you

Dummy text acts as a placeholder.

can change later on. (If you are going to be working on an ongoing title, you can type in the actual name of the book instead of dummy text.)

STEP 13: ADD COMMONLY USED LAYER GROUPS

At this point, you should add the other most commonly used layer groups. If you don't include them in your Master Page Template file, you'll have to create them manually on every page, every time. So save yourself time and create them now. Here are the layer groups you should create:

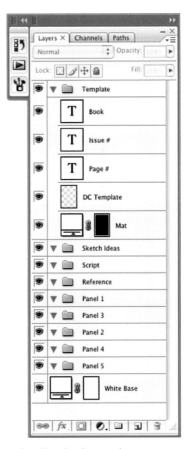

- Sketch Ideas. This is where you'll sketch and keep gesture drawings and ideas for images while you are reading the script during the roughing stage.
- Script. This layer group will hold the script for any page you're working on, so that if you need to refer to the script while drawing, you won't need to change programs or refer to a piece of paper. The script will be right there in the file you're working in.
- Reference. Here, you'll place any references for characters and settings that you will need for a project.
- Panels 1 through 5. I add these five layer groups because an average page has five panels. The sketch work for each panel will have its own layer group to keep everything organized. If you end up working on a page with fewer panels, just delete the layer groups you don't need.

I include these layer groups in the Master Page Template because they are permanent, comprehensive layer groups that you will use in later steps of the production of nearly every page and project.

Keeping the script and all the reference materials in the same file, in their own layer groups, saves time because you don't have to look for them in multiple places on your hard drive or riffle through sheets of paper piled on your work table.

As part of this step, you'll want to set up the Script layer so that it's easy and convenient to use. In the Script layer group, add a new Solid Color Fill layer, set it to white, and name it "Script White." This will provide a white base so that when you make the Script layer group visible by clicking on the "eyeball" icon in the Layers palette, it will hide everything you are sketching underneath it, and you can read the script unhindered.

Now, select the Text tool and draw a vertical text box on the Script White layer. This box should take up about two-thirds of the document. The script will go in this text box. I leave an open area off to the side of the script so that I have a blank area in which to sketch quick gesture drawings or jot down ideas for each scene as I'm reading. After I'm done reading and sketching, I then drop those sketches into the layer groups for the appropriate panels.

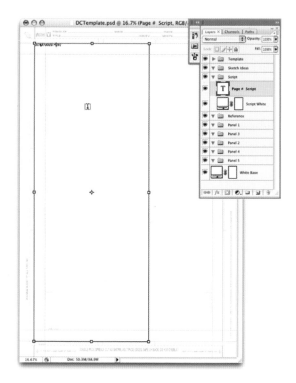

I set up the Script layer so that the script appears in the vertical text box at the left, leaving the white space at the right for making quick sketches as I read.

STEP 14: FINISHING AND STORING YOUR MASTER PAGE TEMPLATE

Save your Master Page Template as a Photoshop document. You have now created the base for every file you will draw digitally.

I recommend that you store your Master Page Template file along with other reference and time-saving resources—such as custom paths, actions, stat libraries, and anatomy references—in a folder called "Master Reference." This gives you a common resource point, in one spot on your hard drive. (I talk more about creating time-saving libraries in chapter 7.)

CUSTOMIZING YOUR MASTER PAGE TEMPLATE

Here, I took a bunch of reference shots from previous issues of *The Flash,* along with some drawings I did myself, and created collages of each character I'd be drawing for the series, putting them all in the Reference layer group for easy access later on. (The artwork shown here that I didn't draw is by Daniel Acuña and is from *All-Flash #1, The Flash #231,* and *The Flash #232.*)

Be sure you always keep your Master Page Template just the way we left it above in your Master Reference folder. That way you can always go back to it at the start of a new issue or project. When you do start a new batch of pages or a new comic issue, I suggest you copy and customize the Master Page Template for that book by adding references and paths that specifically pertain to that issue.

Whenever I start a new project—as when I took over illustrating *The Flash*—I make a copy of my Master Page Template and customize it for that new book, first by adding the book's logo to the top of the Master Page Template.

If you are working on a series of pages that contain the same characters, you should add the character or equipment references that you've scanned (or your editor has emailed to you) in the Reference layer group.

(Left) Each time you start a new page, save it by going to File > Save As. Name it according to the book, issue, and page number, both in the Save As dialog box and at the top of the document in your Template layer group.

(Right) Another way to customize your Master Page Template is by adding the chest symbol path, badges, and other accoutrements (such as glasses or goggles) of the main characters you'll be drawing. Since I do so much perspective work, I also include a perspective path in the Paths palette of my Master Page Template to save time, so I won't have to go to my hard drive and open it from there.

7
TIME-SAVING LIBRARIES

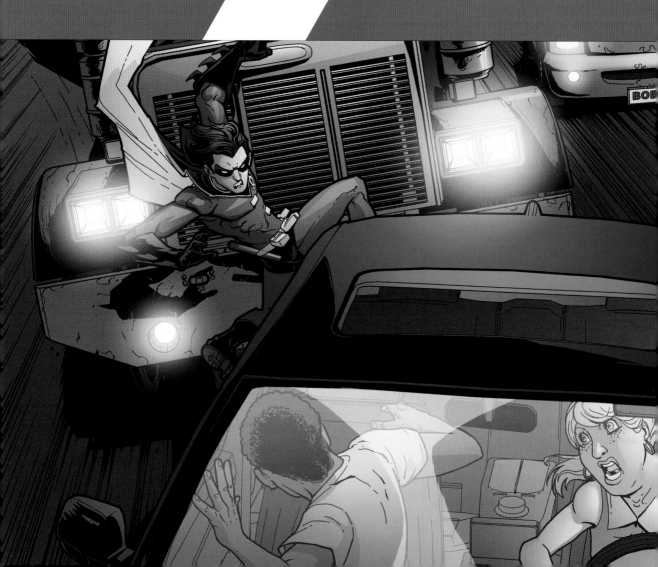

A huge benefit of a digital workflow is the efficiency that results from reusing work you have already done. The endlessly reusable Master Page Template we created in chapter 6 is a great example of this, but it definitely doesn't end there. It's important to automate routine tasks whenever possible. It may take some time up front to set up that automation—drawing full, reusable backgrounds, for instance, or creating extensive path collections—but the time you save later will more than make up for it in the long run.

BUILDING AND MAINTAINING A MASTER REFERENCE FOLDER

In the old days, creating an extensive reference library was like getting a part-time job as a librarian. My traditional reference collection had references of all kinds: photos, magazine articles, photocopied pages from anatomy books, and photocopies of pages of books on wildlife and cars, as well as references that had been mailed to me for whatever project I was working on. All these pages were neatly hole-punched and filled up countless three-ring binders. Even though I was organized, my reference collection eventually got so confusing and cumbersome that I just stopped using it.

Now my entire reference collection is digital. I cherry-picked through my traditional reference collection and scanned the best pieces. If I see a strong reference image on the Web, I work that into my Master Reference folder as well. And any time an editor mails me a physical reference image, I scan it and keep it in a project-specific digital folder.

The artwork opposite is page 1 of *Robin* #167 (colors by Guy Major).

I keep a Master Reference folder on my hard drive, and I suggest you do the same—saving everything you might reuse or may want to refer to later. Your Master Reference folder is a nexus for everything that will save you time. When I rough out pages, trying different variations on angles and poses, I sometimes come up with dynamic poses that don't quite fit the scene I'm drawing, and I even save those poses as JPEGs in my Master Reference folder for possible future use.

I keep all my path libraries, reusable stat backgrounds, custom brushes and textures, anatomy and photo references, page templates, Photoshop tool presets, and custom actions in my Master Reference folder, and I back it up regularly.

Here is an example of a pose I initially sketched out for *Firestorm* #31. The pose ended up not working out for the story, but I liked it enough to save it in my reference folder for future use.

LOWERING IMAGE RESOLUTION

When saving images to my reference folder, I bring their resolution down so that the file size is small and doesn't eat up much hard-drive space. The low-res file may be fuzzy if printed out, but it looks clear on my monitor, and that's the important thing. The JPEG settings shown in the screenshot at right are my standard settings; I even use them when emailing low-resolution JPEGs of my roughs and inks to an editor.

To lower a file's resolution, go to Image > Image Size. First, make the image's resolution 72 pixels/inch, and then set the height at 950 pixels. It's important that you adjust the resolution first, then the height; if you do it the other way around, the resolution will readjust itself automatically. After you have resized your document, go to File > Save for Web & Devices. Next, select JPEG as the file type, with a quality of 55.

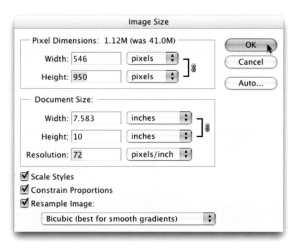

SAVING FOR THE WEB

Any time you are saving a JPEG, use the Save for Web option in Photoshop. This saves a bunch of space on your hard drive and makes the files faster to load and email. The Save for Web options compress the JPEG file partly by merging similar hues, making them the same color. For instance, if your image contains two similar flesh-tone shades, the compression will make them the same shade, thus saving file space. With a JPEG quality of 55, the compression isn't all that noticeable, but if you use a lower level of JPEG quality, the effects of the compression (including fuzzy patches of light and dark, called "artifacts") become more visible.

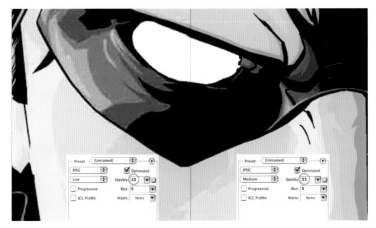

This close-up from the cover of *Robin* #173 shows the low-quality compression of 20 on the left and the medium-quality compression of 55 on the right. Side by side, the difference in image quality is obvious.

CREATING A REUSABLE PATHS LIBRARY

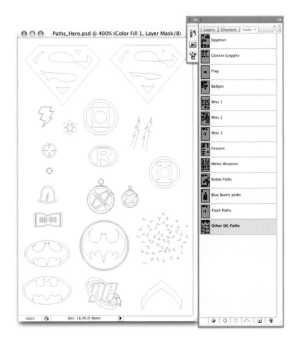

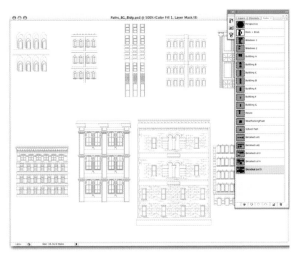

(Left) I keep one Photoshop file for chest symbol paths for all the characters I regularly draw.
(Right) I also keep a Photoshop file for custom-built building faces, which I use for cityscape backgrounds.

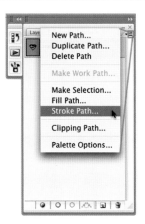

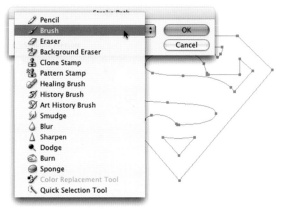

Paths themselves do not make a printable line until you stroke the path onto a layer. To stroke a path, access the drop-down menu at the top right of the Paths palette and select Stroke Path.

When you select Stroke Path, a dialog box will appear, asking which tool you would like to stroke the path with. You can stroke the path with a variety of tools, but I almost always use the Brush tool.

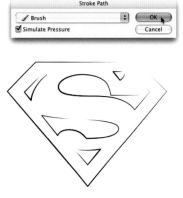

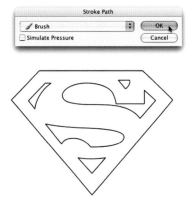

If you check the box for Simulate Pressure, the stroked path will take on a fluid, hand-drawn style.

With Simulate Pressure unchecked (which is the setting I usually use), the stroked path looks like it is drawn in a "dead line" style, with the line weight perfectly consistent throughout.

Paths are vector shapes that are usually used in vector art programs like Adobe Illustrator. But paths can also be used in Photoshop in a way very similar to how stencils, French curves, and patterns are used in a traditional workflow. Paths are reusable, and, because they are vector shapes, they can be distorted and scaled to any size without losing resolution. I keep two Photoshop files with a myriad of paths in them, one file for chest symbols and the other for building faces.

The main benefit of a library of paths is that it keeps path-created elements consistent. For example, once you've perfected a super hero's chest symbol path, you can reuse it—and keep it perfectly consistent—from then on. The symbol will always look like it's really imprinted on the super hero's chest. Using a path to do this is a real time saver, because it requires only minimal effort.

CREATING PATHS FOR BUILDING FACES

Since paths can be distorted without any loss of resolution, they are ideal for creating perspective grids as well as building faces and windows.

A few years ago, I started taking digital photos of interesting architectural features and window structures I saw and then creating paths for them in Photoshop. I do this so I can use these images repeatedly for background buildings in my drawings. The illustrations in this section show you how I do this.

STEP 1: SELECT A BUILDING FACE

I took this photo in New York City, just a few blocks from the offices of DC Comics. The middle building has a cool architectural style, and its windows have great balance. Now we're going to make a building face path for it.

First, using the polygon Lasso tool, make a selection around the face of the building. Then duplicate the selection to a new layer by going to Layer > New > Layer via Copy, and name your new layer "Building."

STEP 2: ISOLATE THE BUILDING FACE

Then place a Solid Color Fill layer, set to white, under the Building layer. This will isolate the building from its surroundings.

STEP 3: DISTORT THE BUILDING FACE

Now that you have the building on its own layer, transform it by going to Edit > Transform > Distort. The purpose of this step is to remove the perspective from the building face by distorting it. Using the squares at the four corners of the bounding box that appears, manipulate the layer so that the windows in the building are square. You can drag down guides from your rulers, which will help you get the building aligned perfectly straight up and down. Hit the return key when you're finished and the bounding box will disappear. Now the building looks like it's facing straight at the camera.

STEP 4: LIGHTEN THE IMAGE

After you have the building face squared, feel free to clear your guides away under View > Clear Guides, as you probably won't need them again. Next, lighten the image by going to Image > Adjustments > Levels. In the Levels dialog box, adjust the middle slider (the gray arrow) to make the building lighter. You need to do this because the paths you're about to create will be easier to see on top of a lighter image.

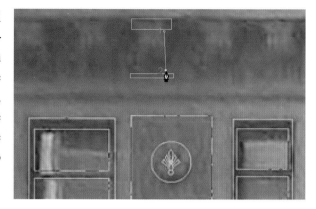

STEP 5: DRAW AND MANIPULATE PATHS

Go to the drop-down menu at the top right of the Paths palette and select New Path. Using vector tools, primarily the Pen tool and the vector Rectangle tool, look for repeating elements in the building, focusing on those first.

To path out this piece of trim (called a corbel) at the top of the building face, first use the vector Rectangle tool to create a top and a bottom. Then, using the Pen tool, create a path for the side of the corbel by clicking once at the top to create the first anchor point and then again at the bottom to create a second anchor point, with a path connecting them.

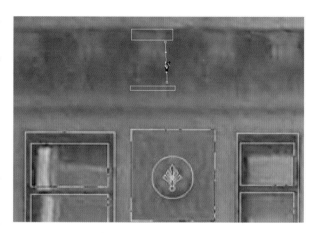

With the Pen tool still selected, add an anchor point in the middle of the path.

Now, hold down the command key (on a Mac) or the control key (on a PC). The Pen tool will temporarily turn into a white arrow that you can use to manipulate the path. Click and drag the middle anchor point inward to make the path curved. If you'd like to manipulate the curve further, continue holding down the command/control key and move the direction lines of the anchor point. (To manipulate the ends of the direction lines independently, you can hold down the option key on a Mac or the alt key on a PC.)

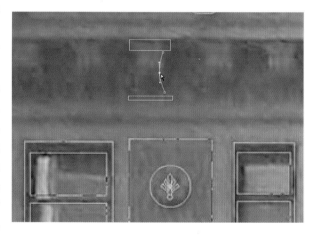

Next, use the black arrow Path Selection tool to select the curving path, then copy and paste it. Go to Edit > Transform Path > Flip Horizontal, and move it to the other side to finish off the corbel.

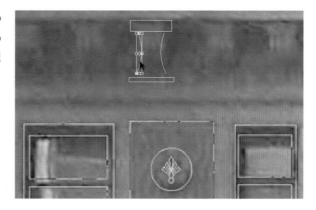

STEP 6: FINISH AND SAVE

In this image, all the major elements of this building have been pathed: two types of windows, an ornamental element, and the corbel path we just created. These elements are repeated throughout the building, so now that we have paths for them, we can just copy and paste the elements where appropriate.

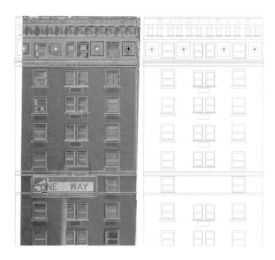

Here we see the end result. The building has been pathed out and finished off with some creative alterations. At this stage you should save the path of the building face in its own file so that you can keep it to use and reuse later on. (In chapter 9, I demonstrate how to construct entire perspective grids and cityscapes from custom building faces like this one.)

CREATING OTHER PATHS

Paths are great, reusable, time-saving tools for lots of other things besides chest symbols and buildings. I've used them for everything from street signs to fences and bricks.

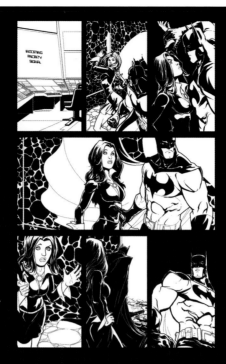

(Left) Here's a path I used for a chain-link fence in *Robin* #154.

(Center) Here's a rock path I used in *Robin* #168. (It's also good for cobblestoned streets.)

(Right) And here's a path for a wrought-iron gate I used in *Seven Soldiers: Mister Miracle* #4.

BUILDING A LIBRARY OF STAT BACKGROUNDS

The term *stat* (as in *stat background*) comes from the old days of comic book production, when production artists used a Photostat camera to take high-resolution photos of inked comic book line art. These photos were used as the black printing plates at the printing press. In those days, when an artist wanted a panel duplicated, he would write "stat background" on the art board, and the production artist would then know to make an extra shot of the line art on the Photostat and then to cut and paste the duplicated element onto the black plate.

Even though we don't use Photostat cameras in comics production anymore, the term *stat* stuck as a way of indicating a duplicated element. Stat backgrounds and other stat elements can be real timesavers, especially when the almighty deadline is bearing down on you.

The way I work—by illustrating a full background and then creating other elements, which I call cardboard cutouts, to place on top of that background—is more akin to traditional cell animation than to traditional comic book art. I feel my method provides a very good reason for creating a library of background shots that, if illustrated and adjusted properly, can be reused repeatedly.

Do be careful, though, not to overuse stat elements. If readers notice that your backgrounds appear again and again, they may feel cheated, and your illustrations will start to feel repetitive. So use them judiciously.

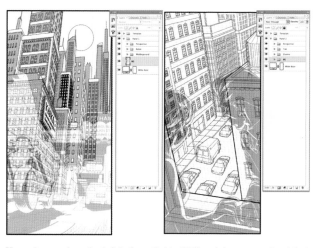

As you create a series of reusable backgrounds, I suggest you save those backgrounds in a Stat folder within your Master Reference folder. They can be used repeatedly to depict the same location or they can be re-dressed and used as backgrounds for different places.

Here, the panel on the left is from *Robin* #160 and the one on the right is from *Robin* #159. As with all the scenes I draw, each background is on a layer by itself, with all middle ground and foreground elements on layers above the background layer. The foreground and middle-ground elements have a white "knockout" layer behind them, which blocks out the background to create my "cardboard cutouts."

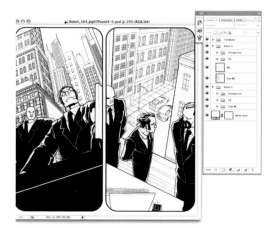

When reading the script for *Robin* #164, I remembered the backgrounds I had drawn earlier, for issues #159 and #160. I brought those backgrounds in and built the new panel around them. In the inking stage, I made sure to re-dress the backgrounds, altering the shadow, sky, and street elements so that it would be hard to detect that they were duplicated. Here, I tweaked the perspective a little by distorting the field of view (see chapter 9 for more on faking a point of perspective), and I rotated the scene a bit to further alter it.

CREATING CUSTOM BRUSHES

Custom brushes can make possible all sorts of unique, easy-to-make looks in the wireframe and inking stages. The process of creating a custom brush is very simple. As an example, let's look at an organic-looking custom brush I made based on a photograph. I took the photo of deteriorating concrete, left, thinking that I might be able to use the pattern for a rocky surface or for the scales on a reptile's skin. So find a similar photo for yourself, and let's make a custom brush.

STEP 1: CREATE OR ALTER A TEXTURE

Start off by altering your image to make it look like line art by going to Image > Adjustments > Threshold and playing around with the threshold settings until the texture has enough detail to make a nice brush texture. Then select the image using the Rectangular Marquee tool.

Alternately, you can simply draw the kinds of lines you want the brush to be composed of. Then, using the Magic Wand or Marquee tool, select the lines you just drew. Whichever method you follow, go to Edit > Define Brush Preset, and give the brush a name that will be easy for you to remember.

STEP 2: ADJUST THE BRUSH PRESETS

In the Brushes palette you can select your new brush in the Brush Presets tab and alter how it works in the palette's other sections. You can make the custom brush's pattern look more random by turning on Shape Dynamics, adjusting the spacing under Brush Tip Shape, and adjusting the Angle Jitter under the Shape Dynamics. You should play around with all these settings, also looking at how they work in Photoshop's preloaded brushes.

STEP 3: SAVE YOUR BRUSHES

As you customize and update your brushes, be sure to save those brushes, just as you back up all your other important files and presets. To save your customized brush presets, click on the drop-down menu in the Brushes palette and select Save Brushes. Remember: Save, save, save! You don't want any of your hard work to be lost.

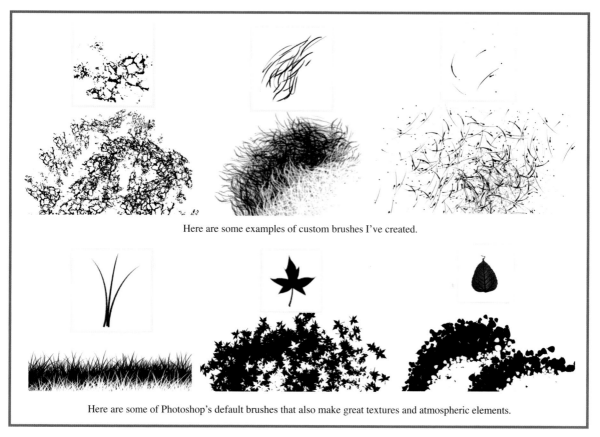

Here are some examples of custom brushes I've created.

Here are some of Photoshop's default brushes that also make great textures and atmospheric elements.

Using custom brushes, you can paint sections black and white on top of each other to get interesting effects that quickly create graphic fields of depth and texture—as you can see in this panel from *Robin* #167.

CREATING CUSTOM TEXTURES

If you have some interesting textures on paper—perhaps one of your favorite zip-a-tone textures (the fields of dots used in older comics for shading)—those can also be brought into Photoshop.

Although it's possible to turn all your custom textures into individual custom brushes, I usually only put a texture into a brush when I intend to use it in a random or sporadic way. With most textures I like to control their placement, scaling, and repetition manually.

For one project, I needed a random spattering effect, so I created an ink-spattered page in the traditional way (with a paintbrush). This way, I got the random, organic-looking spatter effect I was looking for—a randomness that can be hard to create in the all-digital realm.

I keep all my custom textures together in the same Photoshop file, each on its own layer for easy access, and I store the file along with my other reusable libraries in my Master Reference folder.

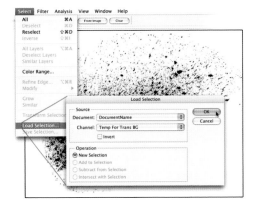

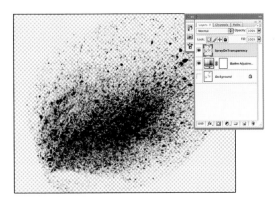

After scanning the spatter in, I selected the entire image and copied it. In the Channels palette, I then created a new channel, called "Temp for Trans BG." The "Temp" indicates that this is a temporary channel, used just to get a transparent background. After creating it, I pasted the spatter into it.

Then I loaded that channel as a selection by going to Select > Load Selection and choosing Temp for Trans BG.

In the Layers palette, I created a new layer called "Spray-on Transparency" and filled that selection with black by going to Edit > Fill. The Spray-on Transparency layer now had the spray texture without any white pixels surrounding it. At this point, I deleted the background layer containing my initial scan, as well as the Temp for Trans BG channel, because I wouldn't need them again. Any texture you scan into the computer will be easier to use if you make the background transparent—so that it won't consist of black pixels surrounded by white pixels. The screenshots above show how I adjusted my ink spatter.

Here are some other textures I've created in Photoshop, to be used in much the same way as zip-a-tone textures. You can just drop a texture like any of these into an area of your art. It will make that area feel richer and more detailed while saving you the time of drawing a complicated texture by hand.

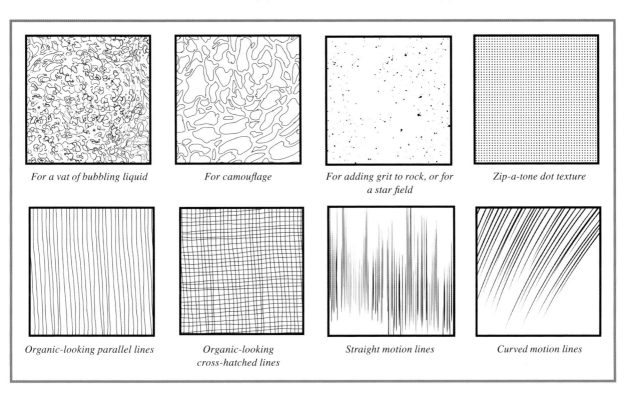

For a vat of bubbling liquid

For camouflage

For adding grit to rock, or for a star field

Zip-a-tone dot texture

Organic-looking parallel lines

Organic-looking cross-hatched lines

Straight motion lines

Curved motion lines

A PORTFOLIO OF CUSTOM BRUSHES AND TEXTURES IN ACTION

I used one of my custom brushes in the background of this panel from *The Flash* #239.

Here, we see my scanned-in spray texture being used as blood in a panel from *Robin* #164.

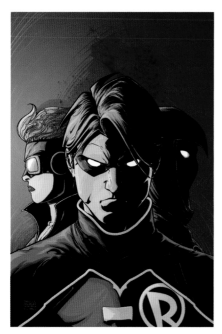

(*Left*) Here, I used the same spray texture in the background of the cover of *Robin* #173. (*Right*) In *Robin* #167, I used a grit-like texture to create the surface of a dirty rooftop, as well as a bit of a gradient as it fades into shadow.

(*Left*) That same grit texture was used in the background of my cover for *Outsiders: Five of a Kind: Nightwing/Boomerang,* but here I reversed it to white for a star field. And my "bubbling vat" texture came in handy for the character Chemo on that cover.
(*Right*) In *Robin* #162, I used the camouflage texture on the pants of a mutant thug.

Curved and straight motion lines, laid down in a texture, give a feeling of speed in this panel from *The Flash* #239.

APPLYING A CUSTOM TEXTURE

In the *Nightwing/Boomerang* issue of *Outsiders: Five of a Kind,* I needed to apply the bubbling texture to some giant mutant bacteria creatures. The screenshots here show how I put the texture into one of the panels. After moving the texture to where it needed to be, I scaled it appropriately for the creatures' size. Since the bacteria creature was so large in the panel, I increased the texture a bit.

STEP 1: INSERT A CUSTOM TEXTURE

To apply a custom texture to a piece of art, just drag the custom-texture layer into the file you are working on, then decrease the opacity of that layer down to 40 percent so that you can easily see through it.

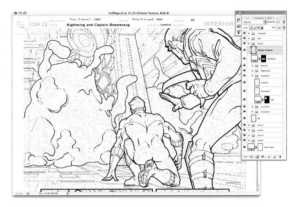

STEP 2: SELECT AREAS FOR THE TEXTURE

Next, make the texture layer invisible by clicking on the "eyeball" icon in the Layers palette. Using the Lasso tool, select the area you wanted the texture to appear in. By holding down the shift key and continuing to draw with the Lasso tool, you can add to the selection. Conversely, holding down the option key (on a Mac) or alt key (on a PC) will subtract from the selection. Using the shift key, you can define the entire area in which you want to apply the texture.

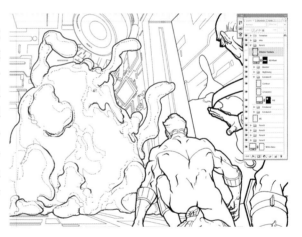

STEP 3: FINISH APPLYING THE TEXTURE

Next, duplicate the texture layer and set it to 100 percent opacity.

I followed these steps for each occurrence of the mutant bacteria creatures, rescaling the texture each time to make sure it looked appropriate for the size of the figure. If you need to dramatically shrink or enlarge a texture you're working with, consult chapter 10 for some tips on resizing.

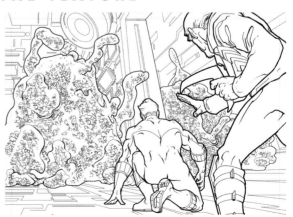

APPLYING MOTION LINES AS A TEXTURE

Motion lines are a great way to convey speed or anxiety, especially when used in combination with detailed background elements. I use them all the time in my work on *The Flash*. The steps shown here are from a page in *The Flash #238*.

STEP 1: INSERT THE MOTION-LINE TEXTURE

As when applying any custom texture, the first steps are to bring the motion-line texture's layer from your Photoshop textures file over to the document you are working on and then to set the layer's opacity down to 40 percent so that you can see through it. This will help you place it correctly.

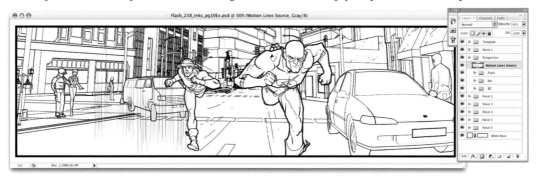

STEP 2: DISTORT THE MOTION LINES

Now, with the layer containing the motion lines active, go to Edit > Transform > Distort. Using the boxes in the four corners of the bounding box, stretch the motion lines so that they look like they're receding into the distance, in line with the image's perspective.

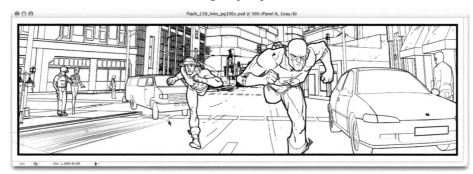

STEP 3: REPEAT AS NECESSARY

If one section of speed lines is not enough, simply repeat the process, applying each new section to the last (so that the sections all meet) until you have all of the motion lines you want.

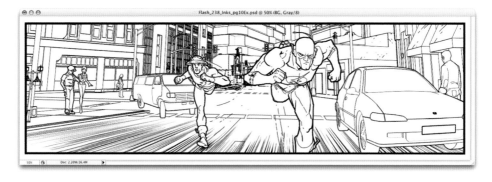

MAKING HALFTONES

Halftones and halftone gradients that mimic old-school zip-a-tones are really easy to create in Adobe Photoshop. And, unlike the old zip-a-tones, you can fuss with the size and direction of the dots until they are just as you want them. Here's how to create a halftone:

First, use the freeform and polygon Lasso tools to select the area you want to create the zip-a-tone gradient within. (My example panel here uses art from *JSA Classified* #34.) We'll keep this selection active until we have applied a gradient within it.

Next, select the Gradient tool, and use the Black, White preset.

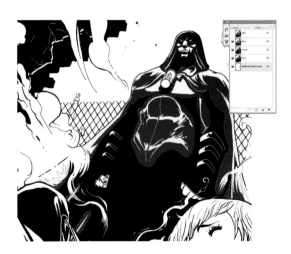

In your Channels palette, create a new channel called "Halftone Grad Temp" and apply a gradient to it with the Gradient tool. You can keep trying different gradients over and over within the same selection, so if it doesn't look just the way you'd like, just try again.

By clicking on the "eyeball" icons of the other channels, you can make them visible and thus see the gradient on top of the artwork. The Halftone Grad Temp channel is set by default to appear as a red overlay.

You can adjust the channel to preview as any color you'd like by choosing Channel Options from the drop-down menu in the Channels palette, making sure the Selected Areas option is selected, and then choosing the opacity and color you want.

When you're happy with your gradient, deselect the active selection you created with the Lasso tool. Next, go to Filter > Pixelate > Color Halftone. (Don't let the "Color" part throw you—this step will work in grayscale mode in addition to RGB or CMYK.) In the dialog box, you may need to play with the numbers a bit until you get the dot size you want, but I usually use a radius of 4 to 7 and a 50-degree angle in Channel 1, with all the others set to zero.

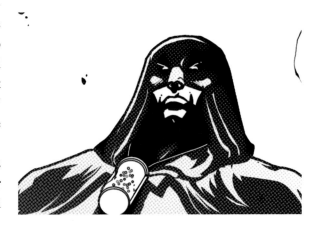

If you haven't turned on all your channels yet, do it now to preview the placement of your zip-a-tone gradient, and make sure the density and frequency of the dots are what you want.

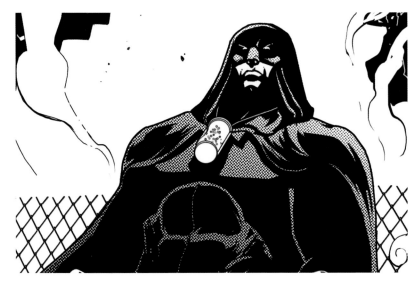

Next, load the Halftone Grad Temp channel as a selection by going to Select > Load Selection.

Make sure you've reselected the RGB channel, and feel free to delete the Halftone Grad Temp channel, as you won't need it again. Then, in the Layers palette, create a new layer called Zip-A-Tones and fill the selection with black.

CREATING A LIBRARY OF
CUSTOM ACTION SCRIPTS

Because I use a Hue/Saturation adjustment layer at every stage of my process, from initial conceptual stages all the way to inks, the first action I created for my digital workflow was an action to generate such a layer. It would be time consuming, not to mention annoying, to have to stop and perform the same steps to create a Hue/Saturation adjustment layer every time one was needed, so I'm going to walk you through setting those steps up as an action—and, in the process, show you that actions are not all that hard to create.

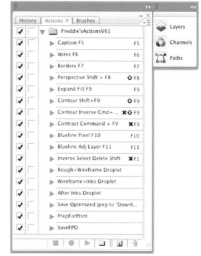

Let's start from scratch. Photoshop comes with some default standard actions; you may want to experiment with them to see if you can glean something useful. These default actions, however, seem to have little use when creating line art for comics, so I just got rid of mine.

To the right are some of the arsenal of actions I've created and collected over the years. They simplify tasks and make my job easier, especially by automating the creation of a Hue/Saturation adjustment layer (seen here as the action called Blueline Adj Layer).

STEP 1: CREATE AN ACTION SET

Start by opening any file and making sure it's in RGB mode. Then go to the drop-down menu in the Actions palette, selecting New Set and naming it "Custom Actions V1." The "V1" (for "version 1") identifies this as the first version of this set of actions. You should adopt this habit of naming each version of an action, so that as time goes on you'll know which version on your hard drive and in your backups is the latest.

STEP 2: NAME THE ACTION AND START RECORDING

Go to the same drop-down menu in the Actions palette, select New Action, and name it "Blue Adj Layer." Set the Function Key to whichever F key you prefer. (I chose the F11 key.) Now, anytime you hit that F key, Photoshop will perform this action. As soon as you hit Record, the round button at the bottom of the Actions palette will appear red and pressed-in, which means Photoshop is now recording.

STEP 3: CREATE A HUE/SATURATION ADJUSTMENT LAYER

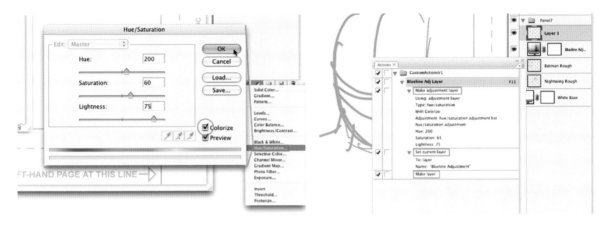

Create a Hue/Saturation adjustment layer. Start by clicking on the black-and-white circle at the bottom of the Layers palette. Then, in the Hue/Saturation dialog box, check the Colorize box and set these values: Hue: 200, Saturation: 60, Lightness: +75.

Since you usually need a new layer for drawing on top of the Hue/Saturation adjustment layer, you should also create a new layer by going to Layer > New > Layer. While you're doing this, you can see in the Actions palette that your activities are still being recorded.

STEP 4: STOP RECORDING

After you've created the new layer, click the square Stop button in the Actions palette. You've just created an action! Not too bad, eh? Since actions are easy to make and can save so much time, always keep an eye out for opportunities to automate steps for resizing files, changing file modes, flattening layers, and so on.

STEP 5: SAVE YOUR ACTION

Every time you add a new action or make an adjustment to one of your existing actions, you should save that set of actions and update the version number at the end of the action set (V2, V3, etc.). To do this, first select the action set you want to save in the Actions palette, then go to the drop-down menu at the top right of the Actions palette and select Save Actions from the drop-down menu.

Photoshop automatically prompts you to save your custom actions in the program's Actions folder, which is a good primary place to store them, but I suggest that you also store copies of all your custom actions in your Master Reference folder. We are saving this set of actions in case Photoshop has to be reinstalled because of a crash, which would erase all your unsaved actions. This has happened to me, and it is devastating! Assuming you are following a backup procedure for your reference collection, you will also now have an easily accessible copy of your actions in that backup in case you get a new computer or want to share those actions with a friend.

My own "must have" actions include the following:

- Bringing down my file's image size and saving it as a JPEG using Save for Web & Devices, so I can quickly save low-resolution JPEGs of poses and sketches for later use, as I discussed earlier in this chapter

- Expanding a selection created by Lasso or Marquee and filling it with black to avoid halos while digitally inking—a technique I cover in chapter 11

- Quickly prepping roughs for wireframes (covered in chapter 8), as well as doing some of the preparation stages required to take a file from the wireframe stage to the inking stage (covered in chapter 9), and, finally, doing some of the things I do with a file after inks are completed (covered in chapter 11)

Although I've just told you to look for opportunities to use actions whenever you can, I have to add a word of caution: You should avoid creating actions that include other actions. If you change the name of one of the actions that another is calling on, or even the name of your action set, which contains your whole list of actions, it may cause one or both actions to break. To be safe, when recording an action, try to perform each step you want that action to perform; this will spare you headaches in the future.

Note, too, that actions have limitations when it comes to naming files. For instance, you cannot create an action that will save a file named "Flash_240_Rough_pg10.psd" to a folder with the new name "Flash_240_Wireframes_pg00.psd." While changing part of your file name may seem intuitive, it requires more intelligence than Photoshop has, and actions just are not sophisticated in this way. For more complicated automations that involve renaming and other advanced techniques, you'll need to use JavaScripting in Photoshop, which I briefly touch on at the end of this chapter.

CREATING DROPLETS OUT OF ACTIONS

A droplet is a little program that calls upon or activates one of the custom actions you've created. Droplets are excellent for batching a group of files and performing the same action on each. For example, if you would like to uniformly size a group of reference files and saved them all out as optimized JPEGs, you could open them all in Photoshop and then manually run that action on each, but that would take a lot of time. You can convert all those files at once by dropping the whole group onto a droplet.

STEP 1: PICK AN ACTION

To create a droplet, you must first choose (or create) an action for the droplet to use as its base. The droplet will perform the steps in that action on as many files as you drop on the droplet. As an example, let's choose an action that resizes files as low-res JPEGs and saves them into a specific folder, following the same steps that we covered at the beginning of the chapter. Once you've picked the action, go to File > Automate > Create Droplet.

STEP 2: SAVE YOUR DROPLET

This will bring up a Create Droplet dialog box, where you'll select the action and say where on your hard drive you want the droplet saved. I suggest that you save the droplet in a new folder called Droplets among your custom actions, so that in your Master Reference folder you will have a Droplets folder in addition to your Custom Actions folder. We'll call this droplet "Resize&JPEG>1_Folder."

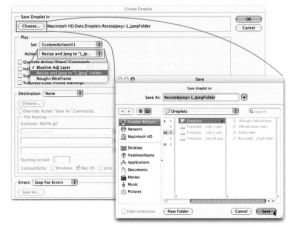

STEP 3: DRAG AND DROP ONTO THE DROPLET

Now, outside of Photoshop, while you are in the Finder or in Windows Explorer, you can grab a bunch of unsorted reference images and drag and drop them all onto the droplet. The droplet will automatically open them and perform the action you've assigned to it on each of the files.

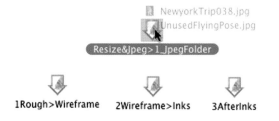

I keep a Project Data folder on my hard drive so that I have a common, centralized place to which actions can save and direct files, as when I'm saving JPEGs for an editor. In that case, the action I've set up always saves files to the folder inside Project Data called 1_JPEGs. I also have an action that performs some of the set-up steps for taking a file containing a rough to the wireframe stage, as well as one that gets a finished wireframe file ready to ink. The files reside in one of these folders temporarily—just until I run them through whatever droplet or action is needed, and then I move them to the Project Data folder for the particular project I'm working on.

What's the purpose of all this? It's so the actions I use always save files to the same place on the hard drive. If I were to create different folders for different issues, designating them as the places to send files for those issues, I might quickly grow confused, especially if I forgot to update my actions to direct files to those new folders. A centralized Project Data folder keeps things simple, because you have just that one place to look for batched files after you've run them through a droplet. Keep your Project Data folder neat and tidy, because it serves as a centralized hub for your files as you are working on them. Older files should be removed and archived when you're done with them.

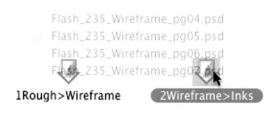

1Rough>Wireframe 2Wireframe>Inks 3AfterInks Resize&Jpeg>1_JpegFolder

Generally, I use only three or four droplets, but I use them for every page I illustrate. I often drop a series of files (maybe five or six files at a time) on a droplet and then go have lunch, answer a bunch of emails, that sort of thing, while the droplet does its work. The size and number of files, the speed of your computer, and the number of steps in the action that the droplet is performing will all affect how long Photoshop takes.

A QUICK WORD ABOUT JAVASCRIPT IN PHOTOSHOP

Adobe Photoshop CS and all subsequent versions support the use of JavaScript. JavaScripts serve a function much like that of actions but are better at understanding those "if/then" statements that actions are unable to execute. This means that JavaScripts can automate processes that are more intuitive and are less rigid in a step-by-step process, looking for factors in file names, layer names, or other elements and responding with complicated behaviors like saving files, renaming them, and more. The only drawback is that you have to learn to write JavaScript.

Writing JavaScripts is far above my head—and beyond the scope of this book. But I am lucky to have a good friend who writes code for a living and who was eager to learn JavaScript to help me out. He has written more than ten custom scripts for me, which has helped me immensely. They do everything from automatically updating book titles, issue numbers, and page numbers in my Master Page Template, to copying the comic book's script from a Microsoft Word document and pasting it into the Script layer group, to saving print-ready files.

There are entire books written on JavaScript, so if you want to create very advanced actions in Photoshop, you should think about getting one. (Some of these books even focus specifically on writing JavaScripts for Adobe Photoshop.)

(Left) JavaScript looks like ancient Egyptian hieroglyphics to me!
(Right) Once a JavaScript is written, though, it's as easy to use as an action.

8 DIGITAL ROUGHS

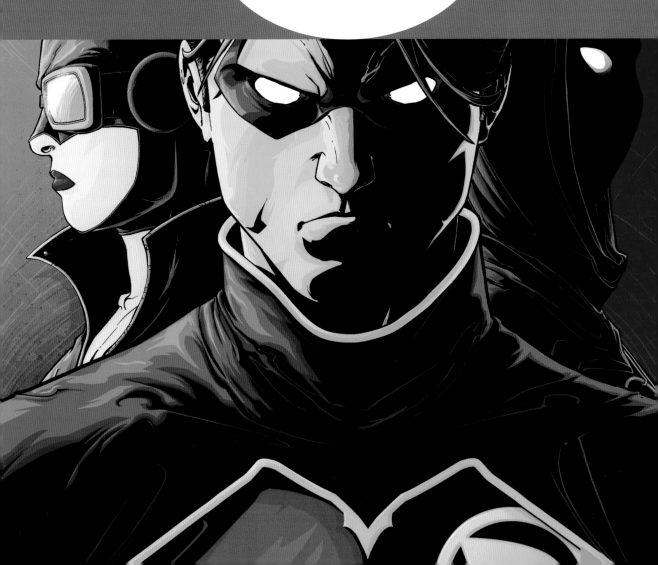

The digital workflow really shines when you're roughing out page layouts. It's invaluable to be able to try new ideas for layouts and poses without erasing previous ideas, just by turning layers on and off. Flipping and resizing layouts is a cinch, and any unused poses can be easily saved for later use on another page.

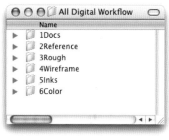

When starting a new comic book issue, I name the main folder for the project with the comic book's title and the issue number, but I always make the same basic set of subfolders to store the files for that project. Those subfolders are named and numbered so that they appear in the workflow order in which I'll create the art. The purpose of each folder inside the main folder is fairly self-explanatory, but we'll be covering each in more detail as we go along.

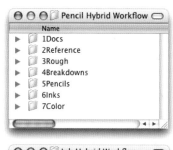

The All-Digital and Ink Hybrid workflows contain the same folders. In the Pencil Hybrid workflow, however, the folder structure looks a little different, with Wireframe being replaced by Breakdowns and the Pencils folder added. The last of the folders in the Pencil Hybrid workflow needs a little explanation: Typically, this folder stores colored proof pages from a colorist or editor, but if you happen to color your own work, the 6Inks folder is a good place to store it, as well.

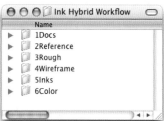

(Right) The artwork opposite is from the cover of *Robin* #173.

On any project I work on, I start by reading the script my editor sends me. After giving it a read-through, I make a list of references I'll need to see in order to illustrate the pages, and I send that list to my editor. One of the many jobs of a comic book editor is to provide reference images to artists when they ask questions like, "For the flashback scene, what should Robin's original costume look like?" When my editor sends me the references, I keep those files stored in the 2Reference folder, which contains only the references for the issue I'm working on. (This folder is not to be confused with the Master Reference folder that holds all your general references and time-saving templates.)

When I'm ready to start my roughs, I copy and paste my Master Page Template into my 2Roughs folder. I then rename the copied template files using this naming convention: Book_Issue#_Rough_Pg##.psd (for instance, a file might be called, "Flash_240_Rough_Pg01.psd". I do this for every page I'm drawing, usually twenty-two pages per issue.

INITIAL SETUP OF
A ROUGH LAYOUT FILES

In addition to any general references that are already in the Reference layer group in my Master Page Template (including, for example, references for regularly occurring characters who may frequently appear in the comic book series I'm working on), I open up each individual Photoshop page file and load whatever specific references are needed for that page.

(Left) Here, I am drawing a two-page Robin origin story for issue #31 of the comic series *52*. Among my references is a layout guide, since all of series 52's origin stories adhere to the same basic layout. Also included are references for the glass case that Dick Grayson's original Robin costume hangs in and for Tim Drake's ninja-esque Robin uniform.

(Right) Next, I grab the script out of the Microsoft Word document my editor provided, selecting all the script for that page of the comic book, and copy it.

(Left) Then I paste that script into Photoshop, inside the Script layer group (set up according to the instructions in chapter 6). If all the text doesn't fit neatly, it's easy to adjust the font and type size using Photoshop's options bar at the top of the screen. With the script in the Photoshop document, I can quickly toggle it on and off as needed (by clicking the "eyeball" icon next to its layer in the Layers palette, which reveals or hides it). This keeps me from having to leave the program to refresh my memory of what the characters are saying or doing.

(Right) Next, I change everything that is not stage direction (that is, the description of movement or action in the script) to a light blue. This allows me to quickly skim when rereading, so that I focus on what is being done rather than what is being said. I do this by selecting a chunk of dialogue or captions with the Text tool and clicking on the Color Thumbnail icon in the options bar at the top of the screen. This opens the Adobe Color Picker, where you can choose any color using the color field, the color sliders, and the color values. I typically use a light blue, but feel free to use whatever works best for you.

When working on large batches of pages, I usually do the steps above for every page in one sitting, because they don't require a lot of creativity and allow me to warm up, preparing my mind for the roughs I'm about to do. Also, I am lucky enough to have a couple of handy JavaScripts that do several of these steps for me all at once.

SKETCH AND LAYER MANAGEMENT

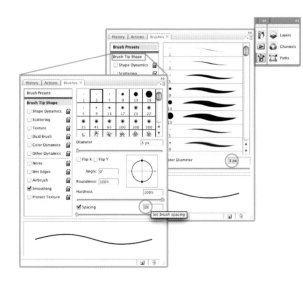

Let's begin designing the page. As pose and composition ideas come to you, sketch them as fast as you can. Faster sketches usually give more energy to the figures, so get your thoughts into a sketch quickly. If you have multiple ideas, simply draw them on different layers. As I begin developing gesture ideas, I use a hard-edge, 4-pixel brush, because line variance is of no importance at this stage.

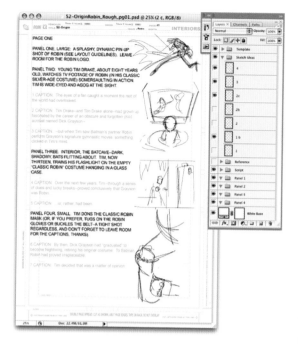

When reading the script, I first make a new layer in the Ideas layer group and then sketch whatever pops into my mind for that panel as I'm reading its description. These should be very simple drawings, so don't get too tight with them. They're just to remind you of what you had in mind later on, when you tighten up the roughs.

As I described in chapter 6, the scripts for my comic book pages (located in the Script layer group of my Master Page Template) take up only about two-thirds of the screen, giving me room to sketch ideas off to the side as I'm reading. It's like having a little storyboard on a separate layer, directly next to the description for that panel.

If you have more than one idea for a panel, that's good: Just turn off the current layer and create a new layer for each idea as you go along. At this stage, it's important not to put pressure on yourself to make anatomy or proportions correct. Just go with the flow and try to keep moving. When sketching gestures, faster is usually better. This is also a great time to try out any unused poses that you've saved in the past and think might work here—either as foundations for new panels or as springboards for new layout ideas.

Once I've created gestures for every panel of the page, I make a new layer, called "B" (for "borders") and rough out my borders with a thicker brush. I use a 10-pixel brush for roughing borders. On this Robin origin story, I had a layout guideline that I was instructed to follow, which helped indicate the configuration of the borders, but usually I just go by whatever panel is the most important "beat" or moment of the page, trying to make it the largest panel on the page and then working the rest of the panels in around it.

(Left) In the Layers palette, I move these idea layers into appropriate layer groups, so that all the ideas for the first panel are in the Panel 1 layer group, and so on. Then I delete the Ideas layer group, as it has served its purpose. (Right) Then I use Free Transform options to scale and transform those quick gesture ideas so that they fit into the panel borders I just laid out. Again, the placement of the gestures doesn't have to be exact. There's still a lot of honing to do, and at this point we're just looking for a ballpark composition.

As I develop a rough layout of a page, I continue to move the gestures around and to rescale them. To find the best solution, it is essential to explore different pose ideas, to flip compositions, and to resize on the fly. Don't feel locked into the ideas you've sketched; sometimes they don't work—but they can still serve as a launching pad for better ideas. If an idea isn't working, just turn off the previous pose idea layer and do another sketch on a new layer.

For the page shown in this series of illustrations, I had originally created gestures that were much more horizontal for panels 2 and 3. But I reworked them to fit into the layout I wanted. Also, I flipped the gesture idea I had for the last panel, at bottom right, so that we can see Robin's *R* chest symbol clearly.

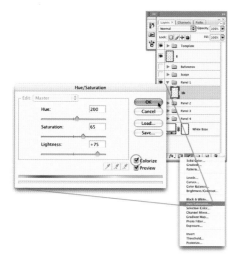

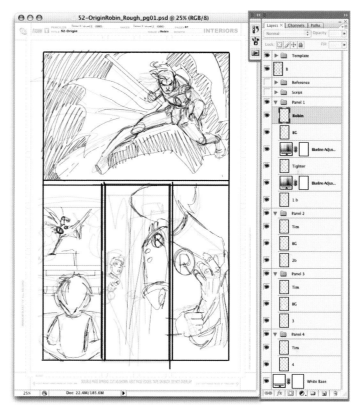

(Left) On top of the gesture ideas in the Panel 1 layer group, I create the standard Hue/Saturation adjustment layer using an action (as described in chapter 7). Then, on top of the Hue/Saturation adjustment layer, I make a new layer, called Tighter, for tightening up the rough poses.

(Right) In every panel, I tighten up the roughs to the point where my editor will understand the overall dynamics of what I have in mind. But I still don't get too hung up on shadow placement or anatomy, because I'm just going for a clear idea of what's happening.

As you are sketching, feel free to try new arm or head positions—without deleting any options you've worked out previously—until you determine which pose works best. When you work on paper, erasing rough gestures within a thumbnail to explore another idea can sometimes result in weaker solutions, but in the digital environment there is nothing holding you back from working out the roughs until they feel right.

After I have tightened up the roughs, I delete any unused layers, including those layers containing the initial gesture ideas. This leaves just the rough sketches that I want my editor to see.

ROUGH CAPTION
AND DIALOGUE PLACEMENT

Now it's time to rough out where the caption boxes and dialogue balloons for the page will be placed, to make sure we give the letterer enough room to work in.

STEP 1: CREATE A LAYER FOR CAPTIONS

On top of the temporary B (borders) layer, create a new layer called "Cap." Set the Cap layer to 50-percent opacity. This is where we will put rough placement for the captions and dialog balloons for the page.

STEP 2: CREATE A WORK PATH

Using the vector Rectangle tool for captions and the Vector Ellipse tool for dialogue balloons, lay out where you think the captions, dialogue, and special effects should go. This doesn't have to be perfect; it's just to make sure you've provided enough room for the letter-er. As soon as you create your first vector shape, Photo-shop will automatically make a temporary path, called "Work Path," in the Paths palette.

STEP 3: STROKE THE PATH

Next, with the Cap layer still active in your Layers palette, go to the Paths palette and click on the drop-down menu at top right. Then fill the Work path with a gray tone from the Color Picker and, using a 5-pixel brush, stroke that path.

At this point, you may want to tweak your layout, moving drawings or captions around to make everything feel balanced. It's easy to move these elements since everything is in its own layer. As I've said, my goal here is not to fully letter the page but just to make clear to my editor and myself that I have provided enough room for lettering. Roughing in the caption and dialogue areas also keeps me from laboring over parts of the design that will most likely be covered with text.

After you have filled and stroked your path onto the Cap layer, you won't need that path anymore, so feel free to delete it. If you don't delete the Work Path, it will just hang around until you create another custom path, at which point the new custom path will override the older one.

Do be sure to save your file throughout this process. The less often you save, the greater the risk that Photoshop (or your computer) could freeze, losing unsaved data. I suggest that you do a save every few steps.

ROUGHING OUT COVER OPTIONS

Roughing out a cover is a little different from roughing a page of sequential panels. In my experience, the editor will send me a one-sentence to one-paragraph description of what should happen on the cover and then let me run with it. I like to give the editor multiple cover options—both to ensure that the cover is dynamic and, frankly, to help me make up my own mind, as I usually have several vivid ideas for each cover and often have trouble deciding which I like best.

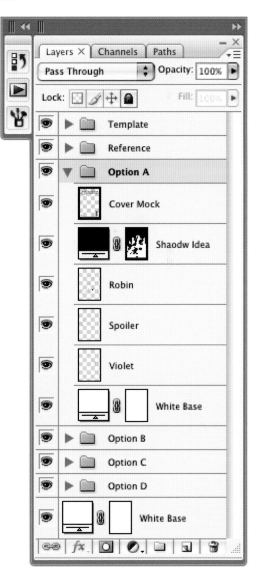

First, I determine the area I have to work in. Comic book covers contain logos, bylines, and other type elements that, along with the UPC, make up what's called the cover's "trade dress." I begin by scanning in a previous cover from the same series to show me the locations and sizes of the elements I need to design around. Then, in Photoshop, I isolate the trade-dress elements and eliminate the rest of the scanned cover. I then scale the trade-dress elements to sizes appropriate to my Master Page Template's dimensions. This way, I can see the approximate area I'll have to work within.

For the sake of clarity, I rough out all my ideas in the same Photoshop file. Even if I have fifteen different concepts for a cover, I keep all those ideas in the same file.

For each new cover idea, I make a new layer group labeled for that option (Option A, Option B, etc.). Inside and at the bottom of the layer group, I place a Solid Color Fill layer to block out any options below it. I also add a corresponding letter designation ("Option A," "Option B," etc.) over the UPC area of the cover, so that when I break these options into individual JPEGs for my editor to review, it is absolutely clear which option we are referring to in follow-up emails.

Keeping all the options in the same file allows me to quickly toggle through them to see which are the strongest and to share poses or elements among the different options.

In the case of this cover for *Robin* #173, the editor decided on a combination of options—the composition of my Option C design combined with the strong light source of my Option A design.

CREATING A JPEG PROOF FOR THE EDITOR

Every editor is different, but editors typically want to see a JPEG of each page at the roughs stage, then at the pencilled stage, and then again at the inked stage. Each time you need to send your editor a JPEG, follow the steps I describe here. The Web-friendly JPEGs you create should be emailed to the editor; if the editor has any notes or corrections, it will be easiest to make the necessary changes in roughs, before moving on to the tighter structure drawings I call wireframes.

STEP 1: FLATTEN YOUR IMAGE

After saving your page rough one last time, flatten your image by going to the drop-down menu in the Layers palette and selecting Flatten Image. If you have any hidden layers, Photoshop will ask if you want them deleted. Click OK, since you are just flattening the file to make a JPEG. You won't be saving over your layered Photoshop file with this flattened version.

STEP 2: RESIZE THE IMAGE

Now go to Image > Image Size and resize your image to 72 pixels/inch (from the previous 300) and make the pixel height 950. Why 72 pixels per inch? Because it's the standard Web resolution as well as the size at which most computer screens are set to display a full-size image. Why 950 pixels tall? Because on most monitors that's as tall as a JPEG can be without the editor needing to scroll up and down to see the full image in an email. These settings more or less ensure that the editor will be able to see the entire image at once.

STEP 3: SAVE AS JPEG

Now it's time to save the image as a JPEG. To save hard drive space, you should optimize the JPEG before emailing it, so go to File > Save for Web & Devices. In the Save for Web & Devices dialog box, select JPEG as the file type and a quality of 55. After you have saved the JPEG in this fashion, close the rough file that is left open in Photoshop without saving it. If you save the file now, it will overwrite your rough Photoshop file with this low-resolution, flattened version, and you don't want that.

A NOTE TO BEGINNERS

When you're first starting out with the digital method, you may want to scan a rough layout you've drawn by hand, then use Photoshop to rearrange and resize elements before printing it out on 11 x 17 paper that you can lightbox and continue to work on in the traditional manner. This will get you familiar with some of the essential tools in Photoshop while also helping you to produce better balanced, more dynamic roughs. It's how I began my conversion to the entirely digital method, and it could be a good way for you to start, too.

9

WIREFRAMES

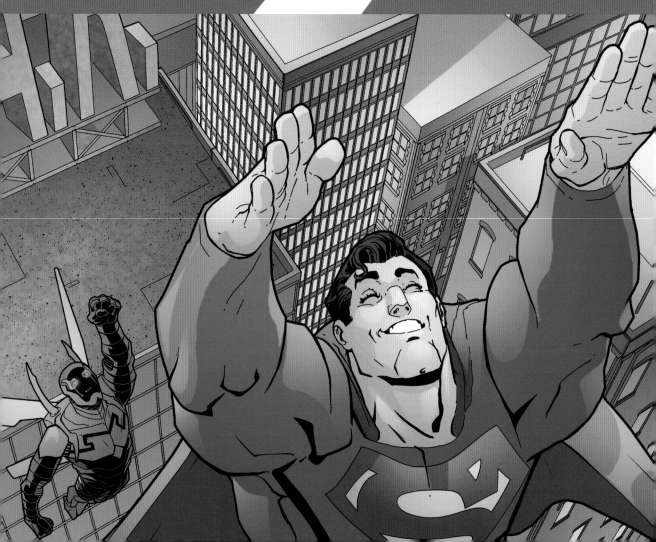

Many artists (myself included) have to fight the instinct to jump ahead and begin rendering a page before making sure the underlying structure is solid. The wireframe step helps in correcting this urge. By forcing you to work on a page's structure until it looks correct—without shadow or rendering to cover up faulty anatomy and perspective—it helps keep your art honest. Drawing wireframes is the most time-consuming step in a page's progression; when working on a page of comic art, I spend more than half the total time just on wireframes.

I use the term *wireframes* for these drawings because they are devoid of lighting or rendering and are drawn with a 3-pixel brush throughout, giving a nice, clean, solid base to "build" the inks on. In this step I also add a "dead" contour line around foreground figures and other major foreground elements to help define their shapes separately from the other elements on the page and to get a jumpstart on the digital inks. In Web design, the term *wireframe* means a diagram showing the placement of all the major elements on a page as it's being designed, which seems pretty appropriate here. Also, the look of my art at the wireframe stage has always reminded me of a wireframe for a 3-D computer model. (Note that if you want to create your pages using the Pencil Hybrid Workflow, you should skip this chapter and go directly to chapter 10.)

After you receive editorial approval for your roughs, it's time to move on to the wireframe step. Start off by saving a copy of the approved rough file into your 4Wireframes folder, and replace the word "Rough" in the file name with the word "Wireframes." As I've said, I tend to work in batches of several pages at a time, so usually I do this for all those pages at once.

The artwork opposite is from page 22 of *Blue Beetle* #15 (colors by Guy Major).

CREATING BORDERS

I always start the wireframe step by laying in the borders on the page (assuming the page is not a splash or pin-up page). This helps me visualize the space I will be working in.

STEP 1: BOX OUT THE BORDERS

With the vector Rectangle tool, draw boxes where you'd like the borders to be, paying close attention to the live area of the page; feel free to use Photoshop guides to line up the vector rectangles with one another.

STEP 2: STROKE THE PATHS

Next, you must stroke the rectangular paths you just made. I like my borders to have a squared edge, so I use a square brush. If you've never used a square brush before, you'll need to load some into your Brushes palette. Go to your Brushes palette, click on the drop-down menu at top right, select Square Brushes, and then click Append in the dialog box that pops up. This will add the square brush set to the brushes you have already loaded. After the square brushes have loaded, select the 10-pixel square brush.

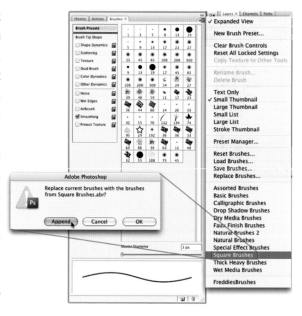

In the Layers palette, inside your Template layer group, create a new layer called Borders, and then stroke your rectangular paths using a square brush. After you have stroked these paths, feel free to delete them, as you probably won't need them again. If your panel border is rounded, you may prefer to use a round brush to stroke your paths. Feel free to experiment to decide what's best for you.

Here, you can see the difference between using a square brush and a round brush when stroking the path of the panel borders. The square brush has a much cleaner, more precise look and gives an exactly squared-off corner at a right angle.

STEP 3: SELECT FOR THE GUTTERS

Next, you will make a mat out of the white spaces between the panels (the gutters) so that your lines can bleed out a little from the edges of the panels without your having to erase them manually. With the Borders layer active, use the Magic Wand tool to select the white areas around the panels.

Then expand the selected area by 2 pixels by going to Select > Modify > Expand.

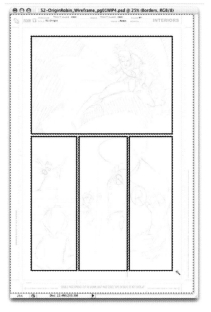

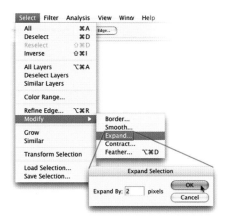

STEP 4: CREATE A SOLID COLOR FILL LAYER

Now, create a Solid Color Fill layer set to white, name it Gutters, and place it just below the Borders layer in the Layers palette. You've expanded the selection by two pixels to create some space so that the gutters won't butt right up against the borders, which can sometimes leave a pixel-wide opening where the artwork under it shows through, depending on the anti-aliasing of the brushstroke used to create the borders. In any case, your borders and gutters are now complete.

I find it helpful to set the Template layer group to 40-percent opacity before continuing. This allows you to see through the borders and gutters if you happen to be sketching outside the panel area. Later, as you're finishing up the file, you can set the Template layer group back to 100-percent opacity.

TIGHTENING YOUR FIGURE DRAWINGS

Now that you have your rough layout all taken care of, you're happy with the storytelling, and you have finalized your panel configuration, it's time to hone those figure drawings. Remember, your figures don't have to be perfect at this point. Just as in our exercise in Chapter 5, we will be sketching and tweaking the anatomy and proportions of the figures until they look totally correct. We'll do this in a very low-pressure way, with maximum versatility, using as many layers as it will take to get the result we're looking for.

STEP 1: TIGHTEN UP THE ART

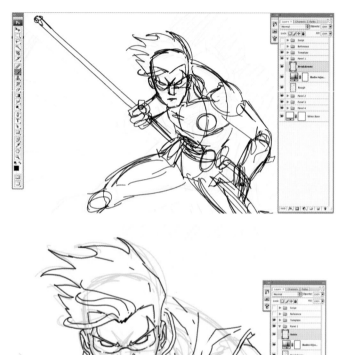

Create a light blue Hue/Saturation adjustment layer above the rough drawing. Then make a new layer, called "Breakdowns," and start tightening up the art. Do this as many times as it takes for you to feel confident in what you are sketching, stacking layers of sketch work and adjustment layers on top of each other.

If you like a part of a particular sketch but want to continue refining the rest of the figure, use the freeform Lasso tool to select that area, then move it to its own layer by going to Layer > New > Layer Via Cut. Then, in the Layers palette, move this new layer above the Hue/Saturation adjustment layer you are working on.

STEP 2: FINALIZE THE LINE ART

As you are tightening up the sketch, scale or rotate elements of each figure to get the proportions correct, until the structure looks good to you and you are ready to move to the finished wireframe. Create a layer for each major character, calling it "[Character's name]LineArt," which I'll call "CharacterLineArt" going forward.

For everything but clothing, I nearly always use a 3-pixel, hard-edge brush when drawing wireframes. If you like, you can certainly use a pressure-sensitive brush for your wireframes, but I personally like the look that a dead-line brush creates. I add the weights and shadows later, in the inking step.

As you're tightening up the sketch, try flipping the image occasionally to see if the structure looks off-balance. (To flip the image, go to Edit > Transform > Flip Horizontal.)

STEP 3: DRAW CONTOUR LINES

Next, create a new layer, named "Contour." Using a thicker brush (here I used a hard-edge, 6-pixel brush), draw contour lines around the major figures and/or objects in the panel. Make the contour lines thicker around objects and figures in the foreground and thinner around the figures/objects placed farther back. These defining outlines give you a head start in the inking process, as well as creating something that is easier to get a selection off of, when using the Magic Wand tool in the next step to creating Cardboard cutouts.

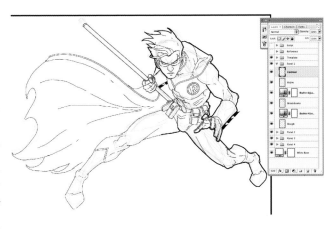

Think ahead. If you are using the Ink Hybrid Workflow, make sure your contours are not as thick as they would be if you were inking digitally. Keeping the contour lines a little thinner will give you a bit more freedom when you ink the page by hand.

MAKING CARDBOARD CUTOUTS

On the left, the cardboard cutouts for a page of *Robin* #159 are in place (and left slightly transparent); on the right are the inks and colors for the page (colors by Guy Major).

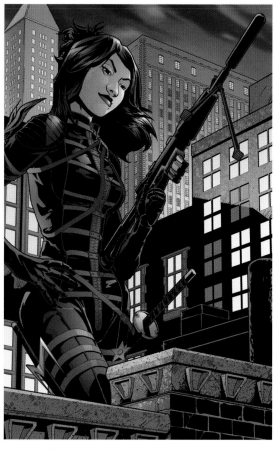

On the left, a cardboard cutout is in place for a page of *Robin* #162; at right are the final inks and colors (colors by Guy Major).

Digitally created "cardboard cutouts" allow you to work in a way very similar to the way cell animators traditionally work. A cardboard cutout of a figure (or an object) is like an animation cell on which a figure (or object) has been drawn but whose background is transparent. One big advantage of cardboard cutouts is that the cut-out elements can be stacked or arranged however you like.

Making a cardboard cutout of a figure allows you to move, resize, rotate, or tweak the character without having to redraw any of the background elements. This is a lot easier than drawing the backgrounds around the characters and then, if a character's size or position needs to be adjusted, having to patch the background to accommodate the changes. It also keeps those backgrounds intact, so that you can potentially reuse them as stat backgrounds. (See chapter 7 for more on creating and managing a stat library.)

STEP 1: SELECT THE MAGIC WAND TOOL

To begin, select the Magic Wand tool. In the options bar, make sure that the Anti-alias and Contiguous options are checked and that the Sample All Layers option is not checked. It's good practice to scan these options, as we will be changing some of them in the inking stage.

STEP 2: SELECT YOUR FIGURE

With the Contour layer still active, click inside the figure you want to select with the Magic Wand tool. This will select the figure's shape as defined by the contour line surrounding it. If the selection leaks out onto the rest of the layer, you may have the wrong layer selected, or your contour line may not go all the way around your figure. If it's the latter problem, complete the contour line, making sure it doesn't have any gaps in it, and try again.

NOTE: SPECIAL CASES

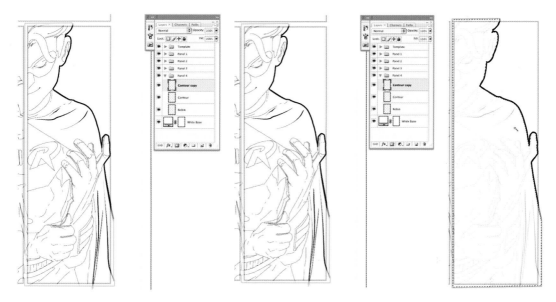

We're going to use the selection shown in the illustration here to create a cardboard cutout. But if you are creating a cardboard cutout of a character or foreground element that is not entirely contained with a panel (that is, an element whose contour stops at the panel's border), you need to perform an additional step when making your Contour layer. In the panel shown here, the contour around the Robin figure is not closed within the body of the panel. If you were to use the Magic Wand tool here, you would select the entire layer, which you do not want to do.

In a case like this, you need to perform a intervening step. First, make a duplicate of the Contour layer and draw a temporary line outlining the whole shape you want to select, as shown. Then use the Magic Wand to get the selection you want. After you've done this, you can delete the duplicate Contour layer, which you no longer need.

STEP 3: CREATE THE CUTOUT

Now that your figure (or element) has been selected with the Magic Wand tool, you can start the process of creating a cardboard cutout. First, expand the selection by 2 pixels by going to Select > Modify > Expand. You're expanding the selection here so that the knockout layer you are about to create will not

butt up against the contour line. If it did, it could create a small gap between the two, about a pixel or so wide, and parts of the image behind it would show through. By expanding the selection, you are making sure that the knockout layer will block out everything underneath it.

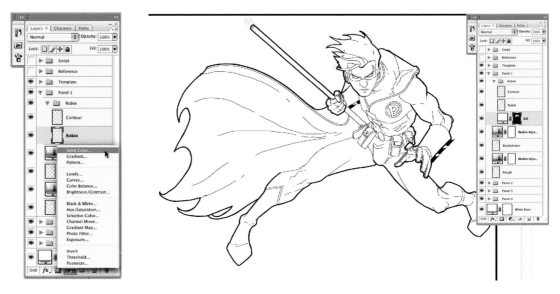

Then make a Solid Color Fill layer set to white. Name it KO (for "knockout") and move it underneath the figure drawing layer. This knockout layer will mask anything under it.

Now place all three of the layers that compose the element—the Contour layer (the contour line), the CharacterLineArt layer (the wireframe drawing), and the KO Solid Color Fill layer—into their own layer group, which will make it easier to keep track of them. You should name this layer group with the name of the character or element it contains. This layer group is what I refer to as the cardboard cutout.

USING CARDBOARD CUTOUTS

What if you have to make an adjustment to the figure? Since a cardboard cutout exists on three layers, making adjustments seems as if it might be confusing. But if the adjustment is a simple one, like altering the shape of the eye or nose, you can easily make the adjustment on the CharacterLineArt layer. If, however, an adjustment affects the silhouette of the character—the character's contour—it's best to delete the Contour and KO layers, make the necessary adjustment in the CharacterLineArt layer and then repeat the process of drawing the Contour layer and making a KO layer from it.

After you've created cardboard cutouts of all the major elements in a panel, you can easily resize those elements and move them around to create better compositions. As you do this, you do have to watch out for *tangents*—the comic artist's term for what happens when the contour lines of two objects line up, creating a confusing spatial relationship

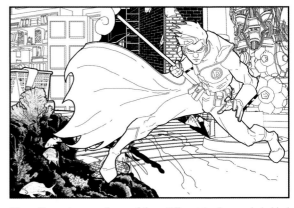

Here, I've put an amalgam of four different backgrounds behind Robin, just to show how easy it is to switch out components with a cardboard cutout.

between them. It's always best to overlap or clearly separate elements so that it's clear where they are in space and how they relate to each other in the composition. Using cardboard cutouts makes tangents—and other compositional problems—easy to avoid with a minimum of redrawing.

USING CHEST SYMBOL PATHS

Super heroes don't often look "straight at the camera" in comic book panels. That means that a super hero's chest symbol is also seen from various angles, so the symbol needs to be distorted and warped to give it volume and make it look like it's actually attached to the character's chest. Symbol paths make this problem much easier to solve in the digital realm. Here are the steps I followed when applying a chest symbol path to Superman in a panel from *The Flash* #23

STEP 1: COPY THE SYMBOL PATH

I started by making a copy of the chest symbol path from the Photoshop file where I keep all my super hero paths. I then pasted it into the comic book page I was working on. If you want to try this yourself but don't have Superman's S-shield as a readymade path, scan a Superman chest symbol from a comic book cover or download an image containing it off the Internet, then create a path on top of it. Once you have your S-shield path ready, copy and paste it into the page you're working on, then duplicate the path in the Paths palette of the file you are working in, so that you will have a clean, unaltered "source path" in the Paths palette of whatever page you are working on, just in case you need to use it again. Then, using the Path Selection tool, highlight the copied chest symbol path.

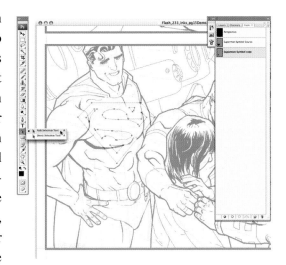

STEP 2: DISTORT THE PATH

Now, go to Edit > Transform Path > Distort, which will bring up a bounding box around the path. Using the four squares in the corners of the bounding box, manipulate the chest symbol until it's in the correct perspective. After you have the perspective right, hit the return key to commit to the transformation. At this point it looks like it's just stuck there on Superman's chest, but the next step will reveal how great this technique is.

Go to Edit > Transform Path > Warp. A nine-sector grid will appear that allows you to warp the contents of the path by clicking and dragging the four points surrounding each of the grid's sectors. As you do this, you're warping the path, rounding it to fit snugly on the chest of our hero.

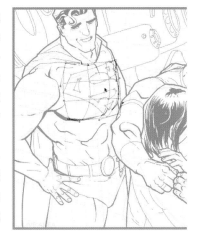

Now stroke the path with your Brush tool, and make any necessary touch-ups. You have to repeat this process for each appearance of a super hero and his or her chest symbol so that it always looks consistent. The process takes some getting used to, but it will soon be second nature.

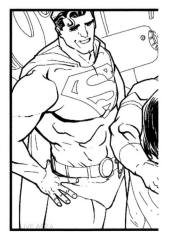

Why bother warping a chest symbol *path* instead of a layer that has the symbol on it? Here's the technical reason: If you stroke the chest symbol onto a layer, it becomes a raster image—an image whose pixels are fixed in a pattern. If the raster image is distorted or warped, the computer must break the pixels into a different arrangement, which may make the lines indistinct or jagged.

By contrast, warped paths remain crisp and clear, because paths are vector shapes that use "geometrical primitives"—points, lines, curves, and polygons that are all based on mathematical equations. No matter how you adjust a vector path, the computer can do the math to change the shape without any image degradation.

The two images here clearly show the benefit of warping and stroking the chest symbol path rather than stroking it onto a layer and then warping it. On the left is the Superman S-shield created by warping and then stroking its vector path; the S-shield on the right was stroked onto a layer and then warped. As you can see, the left-hand chest symbol, created by warping and stroking the path, is much clearer and better defined. The pixels composing the symbol on the right

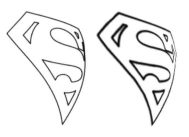

are fuzzy in places and jagged on the far right. At some points the lines almost disappear. But take care: When dealing with vector shapes for chest symbols (or, for example, the faces of buildings), do not stroke them until you've finished distorting and warping them. This will ensure that the images remain as crisp as possible.

RESIZING LINE ART

One reason I draw in RGB mode rather than bitmap mode is that I want my lines to have an anti-aliased edge to them while I'm working on them. In bitmap mode, every pixel is either black or white, meaning that when a bitmapped line is examined at high magnification, it has a jagged edge. In RGB mode, the lines are anti-aliased lines, which means the lines have a softer, more blended-looking edge.

This is especially useful when artwork needs to be resized. Anti-aliased lines are essential when you have to polish up line art that has been reduced or enlarged by more than 10 percent.

Here, on the left, is an example of an anti-aliased line; on the right is a bitmapped line. Anti-aliasing creates a slightly fuzzy edge, which comes in handy when resizing line art. Resizing bitmapped line art can be more difficult.

ENLARGING LINE ART

Here are some shortcuts I've discovered for enlarging line art without having to redraw it after it's been scaled. (We'll get to reducing line art next.) Here are Wonder Woman and Black Lightning as I drew them on page 1 of *The Flash* #235. Black Lightning is farther away in this shot, so he's smaller. Let's say you have a similar drawing, but you decide that you want your figures to be standing side by side. The following exercise shows you how to enlarge the smaller figure and match the first figure's line art.

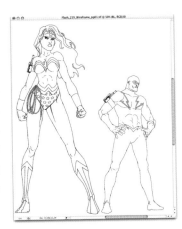

STEP 1: SCALE UP THE SMALLER FIGURE

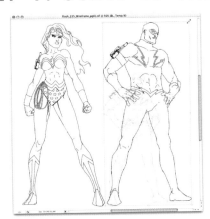

The first step is to select Black Lightning, go to Edit > Free Transform, and scale him so that he's approximately as tall as she is.

 After you scale Black Lightning up, however, the line art gets very soft and indistinct because it's lost resolution as it's been enlarged. The quality of the line, as compared to the line of Wonder Woman's arm and hair, is noticeably weaker.

STEP 2: ENLARGE THE FIGURE FURTHER

To strengthen Black Lightning's lines and bring the quality closer to Wonder Woman's, first select everything on Black Lightning's layer (by going to Select > Select All) and copy it. Then, in the Channels palette, create a new channel, name it "Temp for Enlarge," and paste what you've copied into that channel. Then click *off* the "eyeball" icons next to all the other channels and click *on* the "eyeball" icon next to the Temp for Enlarge channel.

 Next, go to Edit > Free Transform and, in the options bar at the top of the screen, type "200" into the W: and H: fields to scale the line art up to 200 percent.

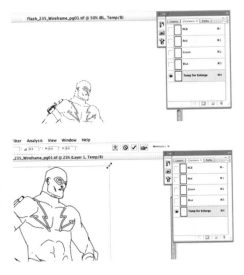

STEP 3: COMMIT TO THE TRANSFORM

Then commit to the transform by clicking the green checkmark in the options bar at the top of the screen. At this point Black Lightning's line art has been blown up so much that lines look really fuzzy. But we're about to fix that.

STEP 4: THRESHOLD AND CREATE A SELECTION

Go to Image > Adjustments > Threshold and change the Threshold level to 60, which immediately makes the line art crisper and decreases the width of the line. Thresholding converts the line from an anti-aliased image, which has slightly lighter pixels along edges of a black line to blend it into its background, into a bitmapped line, where a line consists of either black or white pixels. Feel free to play with the Threshold Level, but I usually use a value in the 50 to 70 range, which makes the line thinner and crisper without making any sections of the line disappear.

Next, load this temporary channel as a selection by going to Select > Load Selection, and, in the dialog box, choosing the Temp for Enlarge layer and clicking OK. After you've loaded the Temp for Enlarge channel, delete it from the Channels palette, as you won't need it again.

STEP 5: FILL THE SELECTION AND SCALE IT DOWN

Now, back in the Layers palette, create a new layer called "Threshold-LineArt" and fill the selection you just loaded with black. Then scale that line art down to 50 percent by going to Edit > Free Transform and typing "50" into the H: and W: fields on the options bar. Align this new art layer on top of the original line art, and then delete the original.

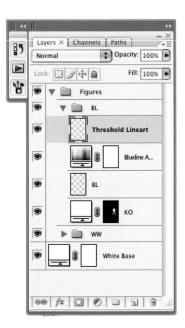

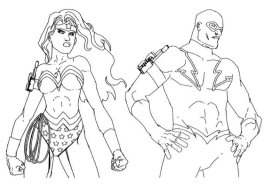

What you've done has been to blow the line art up to a very large size, 200 percent larger than needed, and converted it from a fuzzy mess to a thinner, cleaner line with a bitmapped edge. Then you reduced the line art back down so that the bitmapped edges won't look so jagged. Now, Black Lightning's line art matches Wonder Woman's pretty closely. Do note that when you enlarge line art in this way, details and fine lines sometimes blend together, requiring some cleanup with the Eraser or Brush tools. Even so, the process I've just outlined gives you an excellent place to start working on the enlarged item.

REDUCING LINE ART

Manipulating line art after it's been shrunk is much easier than doing so when it's been enlarged. Here, I took Superman from page 22 of *Blue Beetle* #15 and reduced him (by selecting him and going to Edit > Transform > Scale), so it now looks like he is flying next to Blue Beetle—something I'm sure Blue Beetle would be very happy about! As you can see, the reduction has caused Superman's line art to become so thin that it begins to disappear—and it certainly feels wrong next to Blue Beetle's line art.

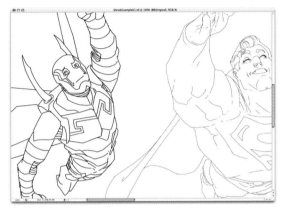

As you can see, the reduction has caused Superman's line art to become so thin that it begins to disappear—and it certainly feels wrong next to Blue Beetle's line art.

STEP 1: BLUR THE LINE ART

To fix this, first make a duplicate of Superman's line art layer, then apply a Gaussian blur to it by going to Filter > Blur > Gaussian Blur. In the dialog box, choose a Gaussian blur of 0.3 or 0.4 pixels. Set the Radius to 0.3, which is the typical setting for blurring a line to fake an anti-aliased edge.

STEP 2: DUPLICATE THE LAYER

After applying the blur, go to Layer > Duplicate Layer a few times to make copies of the layer. This builds up the line weight: Each time you duplicate the blurred line art, the copy builds on the anti-aliased pixels of the image underneath it, making the lines look thicker. If you duplicate the layer five or six times but the lines still aren't as thick as you want them to be, you should select all your duplicate layers along with the original in the Layers palette and, in the drop-down menu at the top right of the Layers palette, select Merge Layers. Then continue repeating the blur-and-duplicate-layers process.

Here, in the layers palette, I have the original shrunken line art layer, another layer that is a copy of it that has been Gaussian blurred, and a duplicate layer of that blurred layer, which approximates the line art of Blue Beetle pretty closely. (For this example, one duplicate layer was enough.)

A final comparison of the original, very thin line art (on the left) and the thicker line art (on the right), shows the difference clearly. Note: When you shrink a highly detailed piece of line art, details or fine lines will sometimes blend together, and—as with enlarged art—some additional cleanup with the Eraser or Brush tools may be needed. But this process gets your line art in the right ballpark, providing you with an excellent base for further work.

CREATING PERSPECTIVE GRIDS AND CITYSCAPES

In Adobe Photoshop, creating an accurate perspective grid or a detailed cityscape is fast and easy.

STEP 1: SKETCH A CITYSCAPE

First, create a new Photoshop document, in RGB mode, and roughly sketch in a cityscape.

STEP 2: DOWNLOAD PERSPECTIVE PATH

Next, you'll need a perspective path. A while back, I created one—it's basically a dot with a bunch of lines coming out of it in incremental steps. I use the perspective path like a compass of perspective; the point in the center of the path is always on the horizon line. To save you the time of creating one yourself, you can download this perspective path file free from my website, by going to www.freddieart.com and looking in the "Digi-Art QuickTools" section. When you first open the downloaded file, it may look like it has nothing in it, since there are no special layers, but just follow the instruction and go to your Paths palette.

STEP 3: DRAG THE PERSPECTIVE PATH INTO YOUR FILE

With the perspective file from my website open along with the Photoshop document you sketched the buildings in, grab the path called Perspective in the Paths palette and drag and drop it from the Perspective file into the building sketch's file.

STEP 4: POSITION THE PERSPECTIVE PATH

Next, zoom way out and position the perspective path off the canvas of the Photoshop document until the perspective lines roughly align with your sketch. Here, I use the Path Selection tool (the black arrow, not the white one) to select the perspective path and then go to Edit > Transform Path to make it larger, so that the center point of the perspective path (the vanishing point) is farther away. As you determine your horizon line and points of perspective, you should follow the same rules you would with any perspective drawing. (If you'd like to read more about perspective drawing, there are many great books out there, as well as online literature.)

After positioning the first point of perspective, create a layer set called "Perspective" in which to store all the perspective layers. Inside the layer set, make a new layer called "R Perspective" (because the vanishing point here will off to the right); then go to the Layer palette's drop-down menu, select Layer Properties, and set that layer color to blue. Color labeling all the perspective layers clearly identifies them as perspective layers and helps you keep them organized.

STEP 5: CREATE A PERSPECTIVE GRID

At the top of the Layers palette, change the setting at the left from Normal to Multiply for the R Perspective layer. Then stroke the perspective path with a light blue color. Setting a layer to Multiply mode makes the layer semitransparent. The lighter a color is on a layer in Multiply mode, the more transparent it will be, so make the perspective lines translucent enough to see any drawing underneath.

STEP 6: REPEAT FOR NEW PERSPECTIVE POINTS

You should repeat this process for as many points of perspective as your drawing will have. This example has three points of perspective, to the right, left, and top of the scene. For each point, I moved the perspective path to the appropriate location and went through the steps outlined above, stroking each new point of perspective in a different color so that I can easily differentiate the directions of perspective when I zoom in on the drawing. In the Layers palette, I also set the color of each layer to correspond to the color I used to stroke its contents.

STEP 7: FINALIZE BUILDING SHAPES

After setting up your perspective grid, create a new layer called "Building Shapes." This is where you'll draw your buildings' shapes. I create these by using the Brush tool, clicking once to start the line and then holding down the shift key and clicking where I'd like the line to end, repeating the process all the way around each building. After establishing their shapes, I create a new Hue/Saturation adjustment layer and make the solid outlines of my buildings light blue.

STEP 8: INSERT AND TRANSFORM A BUILDING FACE PATH

Now you can bring in a building face path. (Here, I'm using the one we created in chapter 7.) Duplicate it so as to preserve the original path, then select the duplicated path and go to Edit > Transform Path > Distort.

Using the squares in the four corners of the bounding box, adjust the path so that it matches the perspective grid and building borders laid out in the previous step.

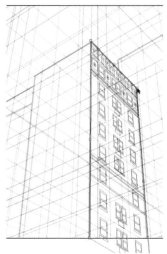

Repeat this same process for the other side of the building, again duplicating the original path and putting it into perspective according to the perspective grid and the building's borders. This assumes you would like both sides of the building to look the same; if not, you can rearrange windows or doors to change things up a bit.

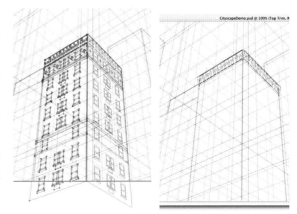

Since this building has a trim, or corbel, that flares out at the top, it's a good idea to treat that element separately from the rest of the building by selecting just the trim part of the building and distorting it so it flares out a little.

STEP 10: STROKE THE PATH

Finally, stroke the building on a new layer and add a thicker contour to the outer edges of the building. And there you have it: a finished building, done without your having to draw individual windows or fussing with perspective all that much. Repeat with different paths, and you'll create an entire cityscape. Each building completed this way will look like it was meticulously created, boosting a great deal of detail without forcing you to labor for hours, tediously drawing individual windows.

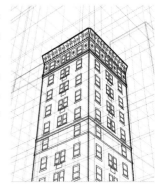

FAKING AN ADDITIONAL POINT OF PERSPECTIVE

Over the last few years, I've developed a quick cheat to trick the viewer's eye into believing that there's an additional point of perspective in a cityscape drawing. This doesn't work all the time, but it can be a useful technique when you're reusing a stat background and want to tweak it to make it look less like the original. The best candidates for this type of manipulation are cityscapes with a perfectly level horizon line, where the buildings are drawn straight up and down. (For some other tips on creating perspective-accurate cityscapes, see chapter 12.)

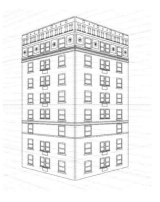

I created this two-point perspective drawing using the same building path I used in the last example. Notice that the horizon line is level; even though there is an indication of depth here, the drawing looks pretty flat. Here's how to cheat this a little:

STEP 1: SELECT THE BUILDING AND ACTIVATE DISTORT

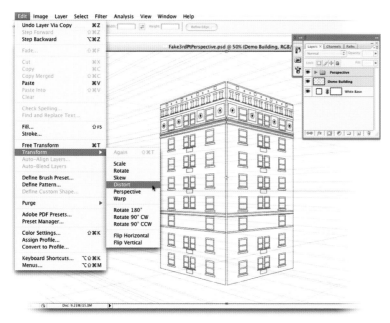

Holding down the command key (on a Mac) or the control key (on a PC), select both the building's layer and the perspective layer set and go to Edit > Transform > Distort. (If you are using Photoshop 7.0 or an earlier version, you will need to link the layers together before you begin the distortion.)

STEP 2: PINCH THE TOP OF THE BUILDING

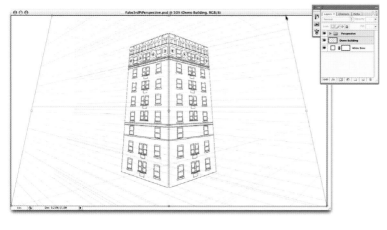

Next, pinch the top corners of the Free Transform box. By holding down the option and shift keys (on a Mac) or the alt and shift keys (on a PC) as you adjust one corner you can make the other corner respond in the same way. This will distort not only the building itself but also the perspective grid, so if you add additional buildings to your scene, it will be easy to make them match the adjusted perspective. Note, however, that you can only get away with this trick to a certain point; if you go too far with it, the drawing will start to look tweaked, so be mindful of how you use it. Since you are distorting raster pixels, the line art can start to get a little funky on you.

CREATING A FISHEYE LENS EFFECT

Although I don't use this much in my own work, a fisheye lens effect can be effective when you want to create an extreme perspective, a disorienting POV shot (where you're looking through the eyes of a character), or a hallucinogenic experience. Here is a fast and very effective way to create the fisheye effect in Photoshop.

STEP 1: START WITH A FINISHED BACKGROUND

To create a fisheye effect, I'm going to use a large background I created for *Robin* #156. Here's the background with all the foreground elements and cardboard cutouts removed. You need to begin with a fully-drawn background, created in the regular way (laying out a perspective grid and applying building face paths), before you apply the fisheye effect.

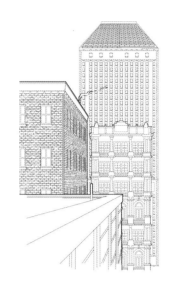

STEP 2: WARP THE BACKGROUND

Go to Edit > Transform > Warp, and a nine-sector grid will appear, encompassing the background art. Pulling the handles at the four corners of the grid sections warps the background so that it becomes rounded, which emulates the effect of a fisheye lens on a camera.

Note that to do this, you must have everything you want to warp on the same layer, as Photoshop does not allow you to apply the Warp transform to multiple layers at the same time (although this limitation might be eliminated in coming versions of Photoshop). If you would like to keep separate elements on their respective layers, you will need to apply the warp to each of those layers separately. One crafty way to do this would be to record an action of the first warp, then run that action on each of the other layers.

Alternatively, you can merge all the separate layers together before applying the warp. If you decide to go that route, I suggest you duplicate the entire panel layer group and then merge that copy and warp it while keeping your original layers in their own layer group, just in case you need to access the individual components later on.

10
PENCILS FOR THE PENCIL HYBRID WORKFLOW

The Pencil Hybrid Workflow is for pencillers who would like to have a physical piece of art on paper, either because they want physical originals to sell later or because an editor asks them for pencilled art that will be sent on to a traditional inker.

When working in the Pencil Hybrid Workflow, you skip over the wireframe step and instead create breakdowns to print out and pencil on top of.

In this chapter I will not be explaining any "how to" pencilling techniques. For that, I highly recommend *The DC Comics Guide to Pencilling Comics,* by Klaus Janson. What I describe here are Adobe Photoshop tools and techniques that digitally aid the pencilling process.

CREATING THE BREAKDOWNS

In the Pencil Hybrid Workflow, the step of creating digital breakdowns takes the place of the wireframes step in the entirely digital process.

In the Pencil Hybrid Workflow, after you receive editorial approval for your roughs, it's time to move on to the breakdown step. Start off by saving a copy of your rough file into the 4Breakdowns folder, and replace the word Rough in the file name with the word Breakdowns. Again, I usually work in batches of several pages at a time, so I do this to few pages at a time.

Opposite is an original, direct-to-color pencil drawing I created for this chapter.

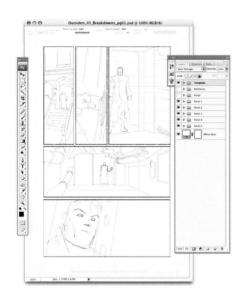

The next step is to create the digital breakdowns. These look like traditional breakdowns and are just a little tighter than roughs. Take your rough layouts (what you end up with at the end of the process described in chapter 8) and tighten them up so that they lay out where everything is going to be on the page a little more clearly. It's a good idea to lay out your perspective grids in this step, which will save you time during the actual pencilling.

PRINTING THE BREAKDOWNS

When you've tightened up your roughs, it's time to print out the work you have done digitally onto art boards. (Printing your breakdowns takes the place of lightboxing in the traditional pencil-and-paper workflow.) Use a large-format printer to print the digital breakdowns onto bristol board in light non-photo blue. When creating hybrid pencils, I print the breakdowns from my Epson Stylus 1280; even though the print itself is a little fuzzy-looking, that's OK, since the shapes being printed are largely gestural. The printed lines will not make it into the final art (as they would if you were following the Ink Hybrid Workflow; see chapter 11).

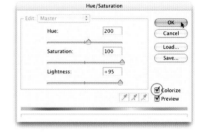

When following these instructions, play around with the file and printer settings to get the right feel. The goal is a printed line similar to a non-photo blue line. Note: If you're printing onto bristol board that already has an art template on it, you should turn off the Template layer group in your digital file before printing. If you don't, the digital template will print over the existing one, resulting in a messy, confusing-looking board.

Although settings and output vary from printer to printer, I have found that printing breakdowns works best with the Hue/Saturation adjustment layer settings shown here. These settings are very similar to those used for our regular Hue/Saturation adjustment layer (see page 41), but this time you go all the way to 100 in saturation and +95 in lightness. Although this will make the line art nearly invisible on screen, it will print darker than it appears on your monitor. This is because of the monitor's illumination, which makes light colors seem to disappear.

(*Left*) Once you have the settings right, print out the digital breakdowns onto bristol board. Make sure the color is dark enough for you to see all the digital breakdowns, light enough that it won't overpower your pencils, and blue enough that the lines will be easy to remove if the page is scanned back into Photoshop.

(*Right*) Pencil directly on top of the printed breakdowns. Because this is the first time you're touching the bristol board, the paper won't have absorbed any oils from your hands. This keeps the paper cleaner for a traditional inker (or a collector who might buy your art).

SCAN SETTINGS FOR PENCILLED ART

The scanner I use is a Mustek 11.7 x 17 scanner, one of the more affordable large flatbed scanners. It doesn't get the best color match when scanning paintings or art prints, but it does a bang-up job on pencilled and inked art. It's also large enough to scan in a whole standard comic book page, which avoids the level of distortion you get if you scan portions of the page and then digitally piece them together.

Your scanner software's interface may look different from mine, but most scanners have similar scanning options. Just do your best, and make practice scans until you get the settings just right.

The standard settings I use when scanning pencils are Color (24 bit/channel), Reflective Scan Source, and a resolution of 400. Why scan the art in color? Because it will allow you to more easily edit out the non-photo blue lines. Why at 400 dpi? Because you want the art to be crisp; it's better to scan it a little larger than needed, so that it will remain crisp when you shrink it in Photoshop.

ALIGNING SCANNED PENCILS

There are many reasons you might need to scan traditional pencils: if you're providing pencils to a digital inker; if you want physical pencils but will be digitally inking them yourself; if you're passing them to an inker who will print them out in non-photo blue before inking; if you're working on a book that's going directly from pencils to color; or if you just want scans of your pencils for your own records. But scanned pencils usually need to be tweaked digitally. As discussed in chapter 5, scanning can create distortion.

STEP 1: SAVE A COPY OF YOUR BREAKDOWNS

To make sure your pencil scan is in register with your breakdown drawing, first save a copy of your breakdowns file into the Pencils folder, replacing the word "Breakdowns" in the file name with the word "Pencils" and saving the file as a TIFF.

Even though your file is layered, you can still save it as a TIFF. Photoshop will ask you if you are sure, because, as the warning box that appears on screen says, "Including layers will increase file size." Ignore this and click OK. You will eventually be flattening this image, but keep it in layers for now.

STEP 2: PASTE AND SCALE THE PENCIL SCANS

After you've scanned your pencilled art, drag (or copy and paste) the scanned pencils into the Breakdowns file, above the Template layer group in the Layers palette. If you scanned the pencils at 400 dpi, the resulting image will be larger than the 300 dpi breakdowns, so you may need to scale down the scan so you can see all of the scanned art in the file at the same time. Name this new layer "Scanned Pencils." Then, using the Rectangular Marquee tool, draw a box that covers the entire piece of art and copy and paste that selection to a new layer that you will name "Scanned Pencils Cropped."

STEP 3: REDUCE THE OPACITY

Now, delete the Scanned Pencils layer and reduce the opacity of the Scanned Pencils Cropped layer to 50 percent. This will allow you to see through the pencils to the digital breakdowns you drew earlier, so that you can register the scanned pencils with the breakdowns.

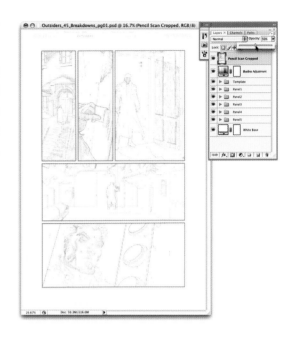

STEP 4: TRANSFORM THE PENCILS

Reducing the opacity allows you to see whether the scanned pencils look distorted when compared to the breakdowns. If the pencilled art does not match up—which it rarely does—go to Edit > Transform > Distort to do a free transform.

If you used your Master Page Template as the base for the template of this page, your should already have Photoshop guides in the file. If you cannot see them, go to View > Extras; that should make them visible. If your file doesn't have guides, you can make the rulers visible by going to View > Rulers. Then, click and drag down from within the rules, creating guides to where the panel borders of the breakdowns file are.

Use any of the four corner squares of the Free Transform box to make the borders or other corresponding lines in the pencilled art align to the borders in the breakdowns file and Photoshop guides. Distort the pencils until all the lines look straight, also making sure that elements of the art itself correspond to the breakdowns file. If you do this in all four corners, the art will align very closely.

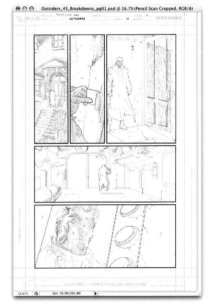

When matching a scanned pencil or ink drawing to a digitally created predecessor, don't just align the template. You should also align the scanned art with the live area, the panel borders, and any design elements in that page of breakdowns. Your goal is to make the scanned art register with the whole digital file as closely as possible.

After aligning the pencils with the breakdowns, bring the opacity of the Scanned Pencils Cropped layer back up to 100 percent. The flatten and save your file.

CLEANING UP PENCILLED ART FOR "DIRECT TO COLOR"

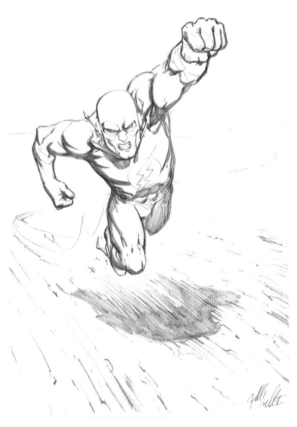

What your editor, inker, or colorist requests of you will determine your next step. If you are not providing pencils to go direct to color, skip over this section and head straight to the "Wrapping Things Up" section on page 117.

If your pencils are being scanned for direct-to-color work, your editor and colorist should be consulted before you start messing with the image, but the following steps should hold true for most direct-to-color requirements.

Here is a hybrid pencil piece I drew for this demonstration. I scanned and aligned it to its breakdowns. The image is crisp and clean, without a lot of pencil smudges or eraser marks, but it can still stand some cleaning up. (If you are scanning pencils for your own archives or to email them to an inker who will digitally ink them or will be printing the pencils in light blue to ink on top of, you do not need to clean up the art nearly so much. I'm preparing this piece as if it were going direct to color, however, so I want extremely clean pencilled art.)

Created using the Pencil Hybrid Workflow, this pencilled art was drawn on top of structure lines I drew in Photoshop and then printed out on bristol board. The scan therefore contains those printed lines as well as the additional non-photo blue lines I drew on the art myself. For most direct-to-color work, these lines need to be eliminated.

STEP 1: BACK UP THE ORIGINAL SCAN

First, rename the Background layer, which is the layer we just flattened in the section about aligning the pencils, as "Original Scan," then duplicate the layer and rename it "Adjusted Line Art." This ensures that if the adjustments don't go the way you like, you will still have the Original Scan backed up.

STEP 2: SELECT COLORS TO REPLACE

The primary way to remove the non-photo blue lines in a color scan is to go to Image > Adjustments > Replace Color. In the Replace Color dialog box, use the leftmost of the three eyedroppers to select the color you would like to affect—in this case, light blue. You can use the eyedropper with the plus sign (+) next to it to add any additional colors you'd like to affect, or the minus sign (–) eyedropper to avoid affecting any colors you don't want to affect. The Replace Color window in the center of the dialog box will show the colors you are affecting, though it may be a little hard to tell exactly what they are just by looking at this window.

STEP 3: REPLACE THE COLOR

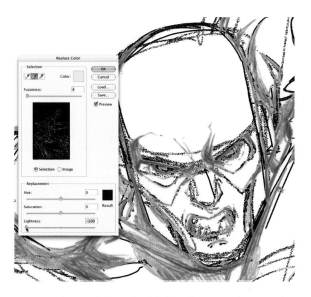

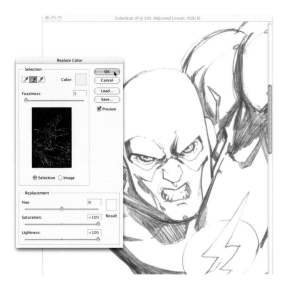

To get a better idea of which colors you have selected, move the Lightness slider all the way to the left, which changes everything you have selected to black. This is only a temporary step to see what you have selected. If you are not capturing all the colors you would like to affect, use the eyedropper with the plus sign next to it, or increase the fuzziness by moving the Fuzziness slider to the right. Once you know you are capturing the right colors, adjust the Lightness slider back to zero (all the way to the left) for now.

Now that you've selected the blues you want to eliminate, adjust the Saturation and Lightness sliders all the way to the right, to +100, which makes the selected shades of blue convert to white. In effect, this eliminates the blue, leaving only the pencils.

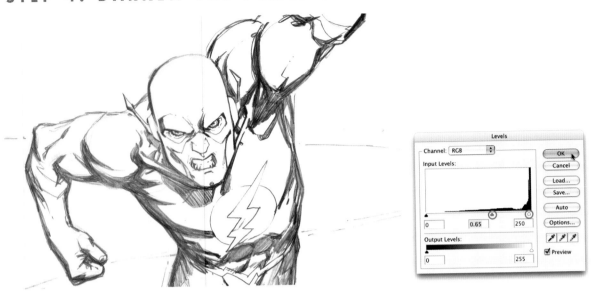

After you have removed the blue from the scan, you'll probably have to make the pencils a little darker. Go to Image Adjustments > Levels. Under the Input Levels window, adjust the middle slider (the gray upward-pointing triangle) to the right to make the middle tones darker. Then move the far right slider a little to the left to lighten those light sketch lines that may be still apparent. Even after you close the Levels dialog box, there still may be some additional cleanup to do with the Eraser tool.

Just to make sure you haven't oversimplified your line art, turn your Adjusted Line Art layer off and compare it to the Original Scan layer. If the adjustments you've made are too stark and you aren't happy with them, delete the Adjusted Line Art layer and start the cleanup process again from scratch.

Here is a comparison of my initial scan (at left) versus the cleaned-up pencils (at right). The cleaned-up version has greater contrast, with no blue lines or extraneous detail, and is ready to go straight to color.

WRAPPING THINGS UP

When you are happy with the cleaned-up pencils, there may still be bits of light blue here and there, which you can get rid of by removing all saturation from the image. To do this, go to Image > Adjustments > Hue Saturation. In the Hue/Saturation dialog box, move the Saturation slider all of the way to the left, desaturating all color out of the image. (You can also change the image mode to Grayscale, but if you are digitally inking the pencils, you'll need the page in RGB mode.) You should now flatten the file and save it—and probably send a low-resolution JPEG to your editor (a procedure I cover at the end of chapter 8; see page 88).

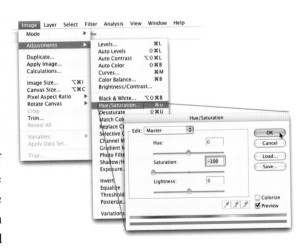

11

INKS

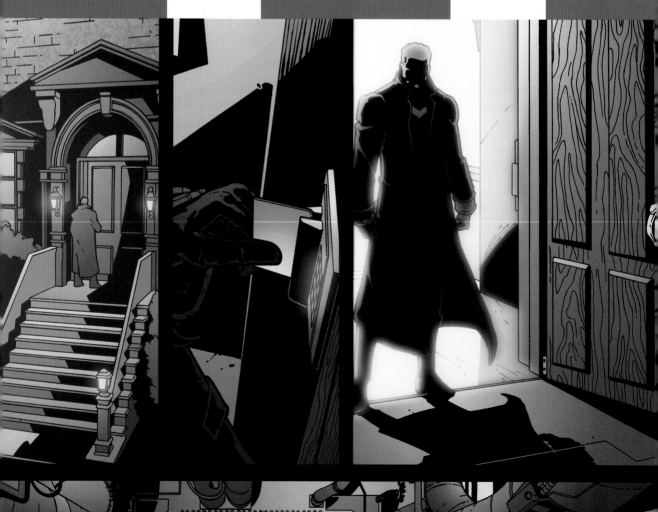

In this chapter I describe the Adobe Photoshop tools and techniques I use to digitally replicate the look of some traditional inking techniques. Once you get used to these new digital tools, inking digitally provides maximum versatility and many timesaving tricks. In this chapter I will not be describing any "how to" inking techniques. For that, I highly recommend *The DC Comics Guide to Inking Comics,* by Klaus Janson.

DIGITAL INKING OVER WIREFRAMES

The main difference between inking over your own wireframes and inking another artist's pencils is that, with the wireframes, you are effectively inking over an empty shell. Inking over wireframes is like doing finishes—filling in the shadows and rendering. Because the wireframes contain no indication of a light source, you also have the freedom to try different lighting schemes.

Inking is where you can make the structure and dynamics of the page really pop. As you see in this panel from *Countdown #3,* the digital wireframes provide a great, structurally sound base for you to ink on. Inks that provide a variety of shadow, depth, and texture can really make the art.

At right is a wireframe (left) and an ink (right) from *Countdown to Infinite Crisis* #3.
The artwork opposite is from page 1 of *Outsiders* #1 (inks by Art Thibert, colors by Guy Major).

When digitally inking over a wireframe, start by saving a copy of the wireframe file into the Inks folder, and replace the word "Wireframe" in the file name with the word "Inks." Once again, I usually work in batches of several pages at a time, so I do this to few pages at the same time.

Since all your lines in the wireframe drawing are already black and you already have contour lines of differing line weights around the figures or other elements, you have a huge head start on inks.

ADJUSTING LINE WEIGHTS

The first thing I do when inking over wireframes is assess the line weights in the art. A primary goal of inking is to create subtle cues of depth by making the line weights of elements in the foreground thicker than those in the background.

To see what I mean by "assessing the line weights," take a look at the back of young Tim Drake's head in this panel. The line weights in his hair and shirt are the same as those in the middle ground and the background. To make him appear "closer to the camera," I'll need to thicken up some lines, which will shows how easily the illusion of depth can be created.

STEP 1: BLUR AND DUPLICATE THE LAYER

To do this, first duplicate the layer that contains the line art for the character or element in the foreground. This will make the line work look thicker. Why? Because the anti-aliasing of the line work is stacking on top of the anti-aliasing of the lines under it, making the lines thicker. If the line still needs to be thicker, duplicate the line art layer again and give it an even bigger anti-aliased line by applying a subtle Gaussian blur by going to Filter > Blur > Gaussian Blur. Use a 0.3 blur.

STEP 2: REPEAT AND MERGE

If the line weight still doesn't look thick enough, duplicate the blurred layer yet again. Each time you duplicate the layer, the line weight will look thicker. Repeat this process until you are happy with the new, thicker line weight. When you're satisfied, merge all the stacked new layers back into the character's line-work layer.

This screenshot shows the thickened line weight, which makes Tim Drake's head and body look closer to the camera. I could easily do this step while working with the wireframes, but I usually don't. Why? If, in the future, I want to reuse part of the line work from the wireframe drawing, I want it to be in the 3-pixel weight I draw wireframes in. That way, I can easily reuse the element or figure without being stuck with an inappropriate line weight.

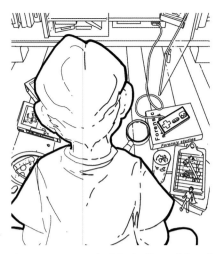

As you can see on the left, the line weights of the young Tim Drake look too thin. On the right, after adjustment, Tim's line weights create more sense of depth; he appears closer to the camera than the background elements.

ON TO THE INKS!

Now that you've adjusted the foreground line weights, making them a little heavier, it's time to get on with the actual inking!

Ever since I started experimenting with different amounts and types of rendering a few years ago, I've kept the rendering elements on a separate layer from the spot blacks, just to make it easy to try out various options. This way, my structure inks can remain untouched while I try different rendering or lighting schemes. If I review a page and find I don't like the rendering inks on an item, I can very easily make adjustments to that item without affecting any of the structure inks.

STEP 1: MAKE NEW LAYERS AND PREPARE THE MAGIC WAND

In the Layers palette, make a new layer group, called "Inks," with two new layers in it: one called "Spot Black," which will contain all the spot blacks, drop shadows, and structure inking, and the other called "Rendering," which is where you will keep textures and everything else that's not shadow or structure inking.

To quickly fill large areas with black, I use the Magic Wand tool. On the options bar, set your tolerance pretty low (around 10) and make sure that the Contiguous and Sample All Layers options are checked. (Before you go on to draw your next set of wireframes, make sure to uncheck Sample All Layers, as this option will complicate the process of creating cardboard cutouts.)

STEP 2: SELECT AND FILL AREAS WITH BLACK

For an area that will be filled with black, close off the area with your Brush tool, then select the area using the Magic Wand. If you haven't closed off the area correctly, the Magic Wand will select additional areas outside the one you want, in which case you'll have to deselect them and go back in with the brush. Once you've got it right, expand the selection by 2 pixels (go to Select > Modify > Expand), and fill it with black by going to Edit > Fill. (By the way, this step provides you with ideal material for creating a time-saving action.) If you do not expand the selection, the area you fill with black will be just a little bit smaller than the area you want and will leave a slight white

halo where the black area meets up with the wireframe lines. When I'm working traditionally and have large black areas to fill, I always think to myself, I sure wish I could just use the Magic Wand tool and fill this area instantly!

STEP 3: USE THE LASSO FOR ORGANIC SHAPES

To get organic-looking shapes when inking, I often use the Lasso tool, set to a feathering of 0 and with the Anti-alias option checked. In fact, while inking, I use the Lasso tool more that any other tool. When inking in Photoshop, I find I work best at about 200 percent to 300 percent zoom, especially when using the freeform Lasso tool. But I encourage you to zoom out (by going to View > Fit on Screen) every once in a while just to make sure you aren't getting stressed out over an area no one will notice.

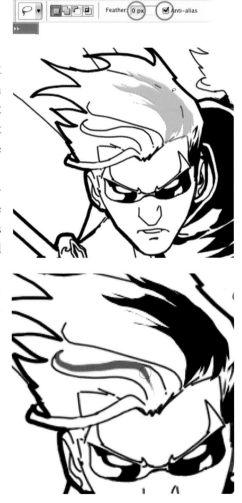

This organic shape in Robin's hair was very easy to create using the freeform Lasso tool. I experimented with the freeform Lasso, drawing a few shapes until I did one I was happy with and then filling that shape with black. (I used red in this illustration, just to make the shape I created clear.)

When inking something organic—or any element that needs a flowing feel—use a large, pressure-sensitive brush set to 9 pixels. A pressure-sensitive brush has a nice, hand-drawn feel to it and gives the feeling of a traditional brush or quill.

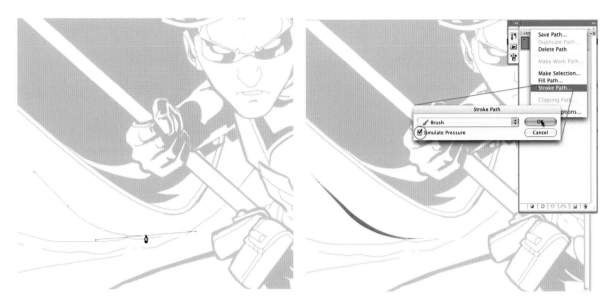

If you want a more controlled but still natural-looking line—especially if the line is long or oddly shaped—use the Pen tool. First, plot out the direction the line should take. Then stroke the path with the Brush tool, with Simulate Pressure on. This line ends up looking hand drawn, or as if it has been inked with the aid of a French curve.

REVERSING STRUCTURE LINES IN SHADOWS AND SILHOUETTES

Digital inking can also be very useful if you would like to add a rim light or invert part of your image. You can cheat by getting some of those lines from your wireframe lines! Say you've drawn a detailed wireframe figure that will be partly or wholly in shadow, such as the hand of the ninja in the foreground here.

STEP 1: USE THE LASSO TOOL

The first thing we need to do is to establish the shadow area of the figure we are working with. Start off by using the freeform Lasso tool to draw the area you would like to be in shadow.

STEP 2: CREATE A SHADOW LAYER

Then open up the layer group that makes up the cardboard cutout for the figure you are shadowing. On top of the KO Solid Color Fill layer, create a new Solid Color Fill layer set to black, and name it Shadow.

STEP 3: RELOAD AND EXPAND THE SELECTION

In the previous step, when you created the Solid Color Fill layer for your shadow, you lost the selection you had for that area. To get it back, go to Select > Load Selection. As long as the Shadow layer is active in your Layers palette, it should be the default option in the Load Selection dialog box. After the selection is loaded, expand the selection by 2 pixels by going to Select > Modify > Expand.

STEP 4: INVERT LINE ART

Then, with the line art layer active, duplicate the line art by going to Layer > Duplicate Layer, renaming this new layer "Inverted Line Art." Then invert the color of the line art from black to white by going to Image > Adjustments > Invert.

STEP 5: NUDGE THE LINE ART

You may notice that where the black lines of the original line work meet the white lines of the inverted line work, the transition can look jarring and unnatural (right). You might need to nudge the inverted line art layer, so that it looks like a rim light, highlighting the original line art (far right).

To nudge the inverted line art layer, first select your Move tool and then use the arrow keys on your keyboard to subtly move all the elements on that layer around. If you'd like to move those elements in a big way, hold down the shift key while you do this. It's a subtle nuance, but it can make the shadow and shape of the inked element look more natural and hand drawn.

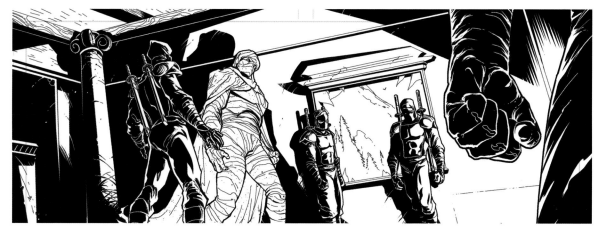

You will still need to finesse the line weights, but using this process creates a good base from which to start. And inking this by hand would take a lot longer.

CREATING EASY DROP SHADOWS

The following technique will not work in all cases, but it's worth trying occasionally because it creates such a cool effect when it does work. So pick a figure you'd like to put a drop shadow behind, and try it.

STEP 1: CREATE A DROP SHADOW LAYER

Start by selecting the layer group containing the cardboard cutout of your figure and duplicate it by going to Layer > Duplicate Group. Then merge that group into a single combined layer by going to Layer > Merge Group. Rename the new layer "Drop Shadow" and move it behind the character's original layer group.

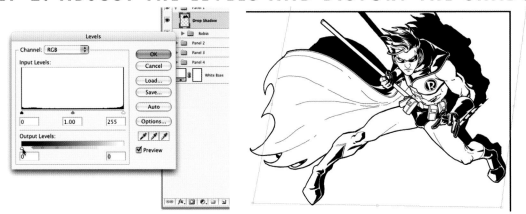

Under Image > Adjustments > Levels, adjust the levels on the Drop Shadow layer to all black by moving the upward-pointing white triangle on the bottom slider to the opposite side, toward the black arrow. There are two sets of sliders in the dialog box; you want the lower set.

Now go to Edit > Transform > Distort. Distort the Drop Shadow layer, making it look like it's receding into the distance behind the character. Cool, huh?

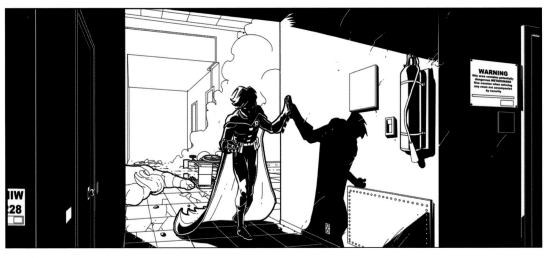

Note that the steps given above won't work for a drop shadow like the one here (from *Robin* #165), where the light catches a cross section of the figure. But for all the light that is hitting the character straight on, this procedure works pretty well.

PATCHES

After I emailed in these pages for a Robin origin story, my editor informed me that I'd drawn the wrong version of Robin's costume in the last panel! With my mistake on Robin's outfit, it seems like a good time to bring up patches. In a traditional workflow, corrections—known as *patches*—are sometimes made with Wite-Out and sometimes with actual patches laid over the original art. In a digital workflow, things work a little differently.

As I've stressed throughout this book, I am very careful to preserve all the work I do. So before beginning a patch, I rename the inks file I've been working on, adding the word "Original" to the end of the file name. Then I

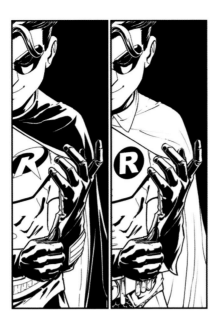

duplicate the inks file and name the duplicate file (where I will do the patch) "Revamped."

(Left) In the Layers palette, inside the Inks layer group, I add a new layer called "Patches." This way, I can turn that layer off and on as I work on the patch, comparing it to the version I already inked.

(Right) In the Patches layer, I draw in white over the areas that need to be covered, just as if I were using traditional correction fluid. Then I make the necessary changes. In this side-by-side comparison, you see the original, mistaken version on the left and the patched revision on the right.

HYBRID INKING

When working in the Ink Hybrid Workflow, start by printing your wireframe file onto art board. When printing these black lines, you want them to be as crisp as possible, so I usually go to my local copy shop and have them print the digital file onto the art board using a very high-resolution printer.

On top of the printed lines, ink the page using traditional, hand-inking tools. The resolution of the print should be high enough that the black printed lines will mesh well with the traditional inks. After you've inked the page traditionally, it's time to scan it back in.

I have my art boards printed on one of the professional Xerox printers that can go up to 2,400 dpi. The higher resolution the better, since the higher the resolution, the more solid and flowing the printed lines will look. You want to steer clear of any printer that may make the printed lines look like a halftone dot pattern, or jagged.

The scanner I use is a Mustek 11.7 x 17 scanner, one of the more affordable large flatbed scanners. Since it's been on the market for several years now, you should be able to find one on eBay for a good price; just make sure you get a USB cable with it. It doesn't get the best color match when scanning paintings or art prints, but it does an excellent job on pencilled or inked art. The Mustek is also large enough to scan in a whole standard comic book page, which avoids the level of distortion you get if you scan portions of the page and then digitally piece them together.

When I ink a page using the Ink Hybrid Workflow, I could just send the physical art board to my editor at DC, but I prefer to scan the inks myself so that I can align the art to the wireframe file and make last-minute clean-ups digitally before I send it off. As I mentioned in chapter 5, scanning usually creates distortion. I'd rather correct this distortion myself rather than assuming someone else will do it.

The standard settings I use when scanning inks are the same I use for pencils: Color (24 bit/channel), Reflective Scan Source, and a resolution of 400. Remember that it's a good idea to scan the art at 400 dpi because you want the art to be crisp. But remember, too, that scanning at 400 dpi can take a long time and a lot of memory. If your computer can't handle it, just scan at as high a resolution as possible—no less than 300 dpi.

STEP 1: SAVE A COPY OF YOUR WIREFRAMES

To make sure your inks register properly with your wireframe, save a copy of your wireframe file into the Inks folder, replacing the word *Wireframe* in the file name with the word *Inks* and saving the file as a TIFF.

Remember that even though your file is layered, you can still save it as a TIFF file. In a warning box that appears, Photoshop will ask you if you are sure you want to do this, saying, "Including layers will increase file size." Just click OK. You will eventually flatten the image, but for now keep it in layers.

STEP 2: COPY THE INKS AND MAKE THEM TRANSPARENT

After you've scanned and cleaned up the inked art, drag or copy and paste the scan into your inks file, placing this new layer above your wireframe structure. The scanned art may be so large that you need to scale it down so that you can see the entire scan in the file at the same time. Name the new layer "Scanned Inks." Then, using the Rectangular Marquee tool, draw a box that covers just the art, and copy that selection to a new layer called "Scanned Inks Cropped."

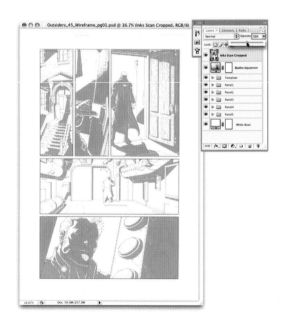

Now, you're going to make sure that the scanned ink matches up with your wireframe drawing. To do this, first delete the Scanned Inks layer, then reduce the opacity of the Scanned Inks Cropped layer to 50 percent in the Layers palette. This will allow you to see through the inks to the wireframes you drew earlier.

STEP 3: DISTORT AND ALIGN THE INKS

After reducing the opacity, you can see whether the scanned inks look distorted when compared to the wireframes. If the inked art does not match up, go to Edit > Transform > Distort.

You should already have Photoshop guides in the Master Page Template you used as the base for your page. Make them visible by going to View > Extras. (If you need to create new ones, go to View > Rulers and drag them off the rulers.) Use any of the four corners of the transform bounding box to make the inked layer's borders align with the wireframe's borders and the Photoshop guidelines. Distort the inks until all the lines look straight. If you do this in all four corners, the art will align very closely. Remember, though, that you shouldn't align just the template; you should also align the scanned art to the live areas, the panel borders, and any other design element in the wireframes—even faces. Your goal is to make the scanned art register with the digital file as closely as possible.

STEP 4: TURN UP THE OPACITY AND SAVE

After aligning the inks with the wireframe, increase the opacity of the Scanned Inks Cropped layer back to 100 percent. Then flatten your file by going to Layer > Flatten Image, and save the file. In a page drawn in the Ink Hybrid Workflow, even if you look very closely, the black lines of the professional printer blend right in with the rest of the inks, matching the line density and thickness of traditional Rapidograph pen lines.

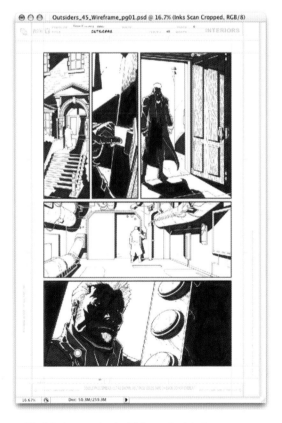

The inks here are by Art Thibert, who inked over my hybrid pencils.

DIGITAL INKING OVER FINISHED PENCILS

Digitally inking over finished pencils is a lot like traditional inking—except, of course, that you'll be utilizing tools in Photoshop. Before you ink over finished pencils, it's important to make sure that the file is in RGB mode (by going to Image > Mode > RGB). This will make it easier to see what you have already inked over.

STEP 1: DUPLICATE THE PENCILS LAYER

You should first save the pencilled file as a different TIFF file, with the word "Inks" in place of the word "Pencils." Now that you are working a new Inks file, rename the Background layer "Original Scan," then duplicate the layer and rename it "Adjusted Line Art." This way, if the adjustments don't go the way you'd like, you still have the Original Scan on its own layer to fall back on.

STEP 2: DISTORT AND ALIGN TO GUIDELINES

Take a close look at the pencil scan and drop down some guidelines, lining them up with any straight lines in the art. It won't be hard to tell if the scan is off. If it is, you need to correct it. To do so, begin by selecting the art and then going to Edit > Transform > Distort.

Distort the Aligned layer so that the printed template's lines are at right angles to all four edges of the Photoshop document. Once the scan is aligned, feel free to delete the original Pencil Scan layer; you shouldn't need it again.

STEP 3: CREATE FILL AND ADJUSTMENT LAYERS
AND PANEL BORDERS

In the Layers palette, create an all-white Solid Color Fill layer called "White Base." You should usually keep this layer invisible by unchecking its "eyeball" icon in the Layers palette, but as you work on the inks, you can switch it back to visible whenever you need to block out the pencil scan underneath, to see only the inks you have drawn. This will help you gauge your progress and the line quality of the inks. On top of the White Base layer, add our old friend the light blue Hue/Saturation adjustment layer, which will turn all the pencils light blue, like non-photo blue lines. I do this because it helps me quickly and clearly see what I've already inked. Next, I suggest that you create panel borders (if there are any panel borders), as detailed in chapter 9 (see page 92).

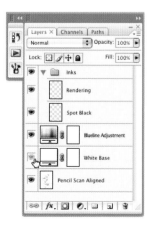

STEP 4: SELECT CLEAN PENCILS AND PASTE INTO NEW CHANNEL

If the pencils you're inking are pretty detailed and clean, you may be able to "cheat" a bit by darkening some of them to make them look like inked lines. Look for areas of really clean, tight, dark pencils, select the white areas around them, and copy them.

Next, create a new channel in the Channel palette from the drop-down menu at top right. In the dialog box that appears, call the new channel "Temp Pencils > Inks" and make sure that Color Indicates is set to Selected Areas. Make this the only visible channel, then paste the copied pencilled art into it.

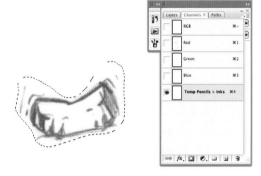

STEP 5: SCALE UP AND THRESHOLD THE PENCILS

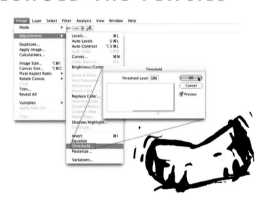

Without unselecting the pasted art, go to Edit > Free Transform, and in the options bar scale those pencils up to 200 percent of their original size. Then hit the return key to accept the transformation.

Threshold the pencilled line art by going to Image > Adjustments > Threshold. Play with the amount of threshold, trying to get those areas as close to a clean inked look as possible.

STEP 6: TURN INTO A SELECTION

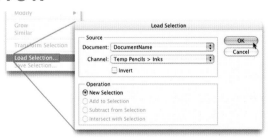

Go to Select > Load Selection and accept the default options in the dialog box that appears. Your transformed art is now a selection. Switch back to the RGB channels in your Channels palette and delete the Temp Pencils to Inks channel; you won't need it again.

STEP 7: FILL AND SCALE THE SELECTION

In the Layers palette, make a new layer and fill the selection with black. Go to Edit > Transform > Scale, and scale the new black line art down to 50 percent using the X and Y coordinates in the options bar at the top of the screen. Most of the jagged lines that came in as a result of the threshold adjustment will disappear. Cleanup may still be needed, but this will give you a shortcut on some of the inks. The rest of the image will have to be inked the honest way!

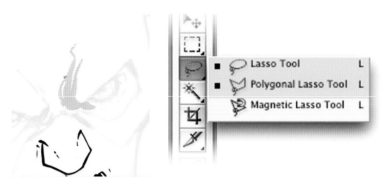

I use a lot of Lasso in my inking, usually the freeform Lasso tool, though I find that I can sometimes get more control with the polygon Lasso tool. The freeform Lasso tool creates organic-looking shapes that can quickly be filled with black.

You can get a perfectly straight line with the Brush tool by clicking where you want one end of the line to be and then holding down the shift key and clicking where you want the other end to be. To get a curved line, simply click the brush very close to where you last clicked, along a curving trajectory. You'll actually be making short straight lines, but if you do it right, they will appear as a continuous curve when you zoom out. This may take a little practice.

Use the Pen tool to craft detailed lines with curves, stroking them when you're happy with how they look. Depending on your inking style, you can use different brush thicknesses and/or different pressure-sensitivity settings.

(Opposite) Here are my own finished *Flash* inks.

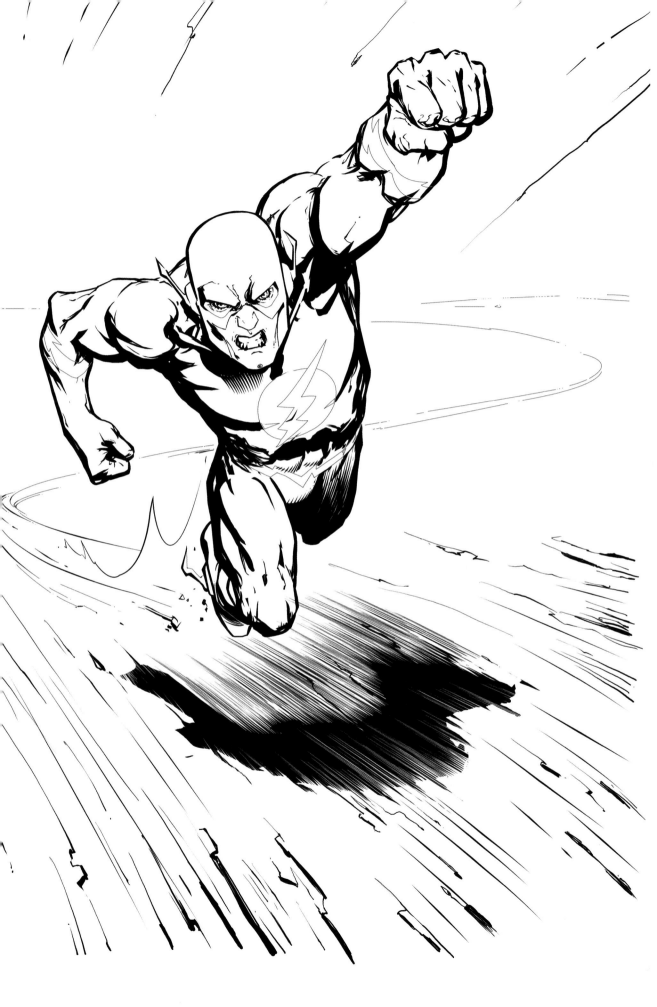

INKING PENCILS WITH MORE RENDERING

The *Flash* piece I just worked on didn't have all that much line rendering, so let's see how to ink a piece that has far more line rendering.

Here is a panel featuring Martian Manhunter from one of my DC portfolio pages, circa 2003. Although these pencils are pretty tight, I don't think I can take any of the pencilled art and convert it to inks because there is just too much texture and grain in the pencils. For areas that call for more precision, I suggest using the Pen tool.

STEP 1: OUTLINE AND FILL SOLID BLACK AREAS

First off, we should establish the areas for spot blacks. You can create spot blacks by using the Lasso tool or the Brush tool, but a more precise way is to use the Pen tool to outline paths and then fill them on the Spot Black layer. Using the Pen tool takes a little longer but provides greater control.

STEP 2: CREATE HATCH LINES

For areas that have tight, parallel hatch lines (like those at the brow line or under the nose of Martian Manhunter), there is a good trick. First, in the Inks layer group, create another layer called "Hatch Lines." Using a 9-pixel pressure-sensitive brush, create a single hatch line that you like the look of. Then, while holding the control and option keys (on a Mac) or the command and control keys (on a PC), click and drag that hatch line. This will create a duplicate of the ink line on its own layer, which you can position as you like. This works best if the lines you want to create are the same size and run in the same direction. This isn't the only way to create hatch lines, but it is precise and fast.

STEP 3: FINESSE LINES AND MERGE

Depending on how exact you'd like to get, however, you can even rotate such lines to create subtle variance in the feathering. Every time you create a new line in this way, it will create a new layer, although they are all contained in the Hatch Lines layer group.

Once you have created all the parallel hatch lines you want, merge them into a single layer by clicking on the Hatch Lines layer group, going to the drop-down menu in Layers palette, and selecting Merge Group. Then merge the resulting single layer into the Rendering layer in the Inks layer group.

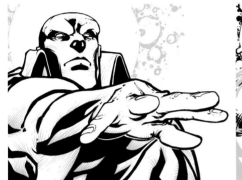 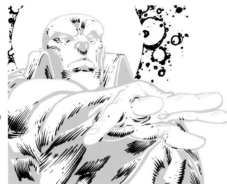

Here are the finished inks, showing both inking layers: the Spot Black layer (in black on the left) and the Rendering layer (in black on the right).

When you have completed your inks over full pencils, convert the file to grayscale mode, but don't flatten it. Just as when you are inking over wireframes, it's a good idea to keep the layers in case any additional adjustments or patches are needed later.

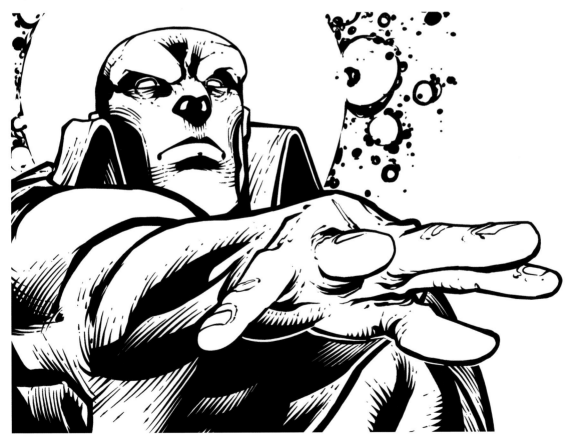

And here are the finished inks, together.

WRAPPING THINGS UP

Regardless of whether you're inking over digital wireframes, following the Ink Hybrid Workflow, or inking over full pencils, you always have to save a low-resolution JPEG for your editor to approve, so take another look at chapter 8, where I cover those steps.

When you've gotten your editor's approval on the inks, it's time to prepare a final, flattened, bitmapped TIFF, which is what almost all colorists expect to receive. The following instructions show you how to convert your layered inks file to bitmap before saving it as a TIFF. I usually put these files in a folder called "UploadedTiffs" just to keep them separate and so that I can keep track of the ones I've already given to the colorist.

STEP 1: SAVE AS TIFF

The first step is to save your file into a separate Up-loaded Tiffs folder, stored in your Project Data folder. Save the file as a TIFF; if your file has layers, it will need to be flattened before you upload it.

STEP 2: COVERT TO BITMAP

All the ink work we've done has used anti-aliased lines, which have shades of lighter gray pixels along their edges. Those anti-aliased lines were a boon to us when we were resizing line work and adjusting line weights, but now they are the enemy!

We need to convert the page to bitmap—black and white only. Black and white art is much easier for colorists to make selections on.

But I recommend against just going up to Image > Mode > Bitmap. Here's why: On the left is a piece of scanned line art that has been converted straight to bitmap mode, allowing the computer to use its default settings to drop out any gray detail or anti-aliasing. A lot of the impact of the line art is lost this way. On the right, the same art has had the bitmap level controlled with a threshold setting of 155. Our goal in manually bitmapping the file (by using Threshold) is to prevent loss of detail and line weight and to ensure that the integrity of the art is maintained.

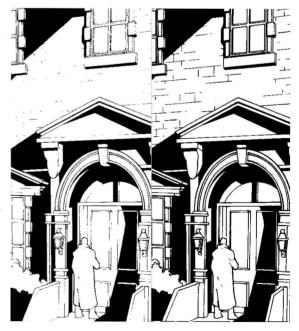

STEP 3: THRESHOLD THE IMAGE

To manually bitmap, first create a Threshold adjustment layer by going to Layer > New Adjustment Layer > Threshold. In the dialog box that pops up you can customize the level for where the line work is converted from an anti-aliased line to a bitmap one. My default threshold setting is 155—it's what I always start at, then I adjust up or down to see which setting gives my page the best look. Feel free to play with the settings until you feel that the bitmapping process is capturing the appropriate level of detail in your inks.

If the inks file you are in is layered, you also have one last chance to adjust your line weights. With the Threshold adjustment layer at the top of the Layers palette, you can go to any layer below it and adjust the levels on it by going to Image > Adjustments > Levels. If you make the layer lighter, the bitmap line will become thinner.

When we zoom in close to the line art, the bit-mapped edge of the line becomes very noticeable. Don't let this worry you: The comic book pages will be printed at a reduced size—about 67 percent of the size of the actual artwork—and the evidence of bit-mapping will virtually disappear.

As you can see here, when we zoom out, the bitmapped edge becomes much less noticeable. It will become imperceptible when color is applied to the image and it is printed.

STEP 4: CONVERT TO BITMAP MODE

After you've finally finished tweaking your line weights and getting your Threshold adjustment layer to the right settings, it's time to put this baby to bed. First flatten your file by going to Layer > Flatten Image. Then convert your file to bitmap mode by going to Image > Mode > Bitmap. Make sure your bitmap setting is 50% Threshold. If your file is still in RGB, you need to first convert it to grayscale mode, then to bitmap. When your file converts to true bitmap mode it should look exactly like the version you used Thresh-

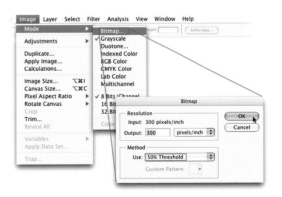

old on, but the file's size will now be a small fraction of the size of the layered grayscale/RGB version you have been working in until now. This makes it ideal for emailing or uploading to an ftp site.

12 LOOKING FORWARD

I love to reflect on the development of comic book art and the craft of making it, from the quickly (and sometimes crudely) drawn art of the 1920s comic strips to the present, when we are using highly sophisticated technology to produce art for the same type of "funny books." Now, a handful of artists are changing the way comic art is created. The industry is undergoing a revolution—a digital revolution that coincides with the rapid evolution of digital technology.

I am honored that I can contribute to that revolution with this book, and I encourage you to join the revolution, too. Keep looking for new ways to create the art you want to create. Reuse what works, but don't be afraid to experiment and try new ways to solve those old sequential-art problems. Ultimately, there is no wrong way of working. Any way that feels right to you is the right way. Follow your gut, have fun, and don't be afraid to experiment. In the end, as long as you're getting the job done and producing the high-quality work they're looking for, comic book editors won't care how you produce it.

The artwork at right is from page 17 of *Robin* #153; that opposite is from the cover for *Robin* #178 (colors by Guy Major).

By the way, I should mention that although Adobe will continue to release new versions of Photoshop, the same tools that I discuss in this book should be available in those new versions, and the thinking behind my methodology should continue to be relevant.

For me, one of the most exciting new developments is being able to create environments consisting of 3-D models for my digitally hand-drawn characters to inhabit. The illustration at right is a good example of what I mean. The background is composed of 3-D models, while the figures were hand drawn in Photoshop.

For years, I've been dreaming of creating fully immersive 3-D backgrounds for my comic book art, but it was only recently that I was able to realize this dream—after a few of my friends referred me to a 3-D modeling program called Google SketchUp.

At the top left is the example I use in chapter 9 when explaining how to create perspectives and cityscapes in Photoshop.

At the bottom left is that same scene, this time created in Google SketchUp. Using the same paths I used to create the face of the demo building, I created a 3-D version of that building. The difference here is that in Google SketchUp I can move the "camera" to any angle I wish. I'm no longer bound by the 2-D constraints of a Photoshop file. I can play around with an endless array of camera angles, then export my chosen "shot" over to Photoshop.

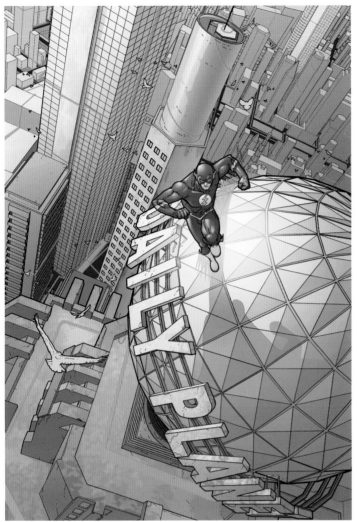

The cover of *The Flash* #237 uses a 3-D environment created in Google SketchUp. When I learned that the cover would feature the Daily Planet Building (I am a freak for all things Superman), I wanted to make sure I got the perspective correct, which can be especially difficult with a rounded shape like the globe atop the Daily Planet Building. So I decided to go all the way with it, making a full 3-D background for the cover.

My wife, Kiki, and I worked together to create the Daily Planet's globe and the building itself, using only Google SketchUp. In this view, the 3-D model of the Daily Planet just looks like a very accurate line drawing.

Then I combined the Daily Planet Building with other custom and stock buildings in Google SketchUp, creating an entire virtual city!

What's even cooler is that all the building face paths I've created in Photoshop can be brought into SketchUp

and extruded to give the buildings depth. This means that I can create entire virtual cities that have the same feel and character as the ones I've drawn in Photoshop in the past. Google SketchUp—which is easy to use and is free—has become a life-saving tool for me. I encourage you to take a look at it, at http://sketchup.google.com.

GIVING MY THANKS

This book represents an almost two-year-long journey for me, but I did not do it alone.
It would be impossible to list all of those people who have made an impact on my art and life,
but I want to give special thanks to the following people:

John Morgan, my editor for this book, for holding my hand through the entire writing process
and championing the book at DC Comics.

Richard Bruning and Peter Tomasi, for giving me a chance at my lifelong dream of drawing comc books.
I owe each of them a life debt.

Jim Mitchel, for being my target reader and giving me a billion excellent suggestions.

George Ryan, Bob Ryan, and Carlo Pascolini, for pushing me to write the book
and making me realize I was working in a way that others may benefit from.

Jay Young, for selflessly writing custom JavaScripts in Photoshop that saved me weeks' worth of work.

But most importantly, my wife, Kiki, for being a constant source of patience, insight, and strength, . . .
You are everything to me.

I've wanted to create a book like this for a very long time. And although I several times questioned
my sanity for trying to write this book while also doing a monthly book for DC Comics,
I have to say it has been an absolute blast!

INDEX